D0477787

Painting the American Heartland in Watercolor

751.42 BEG *10/97*
Beginnes-Phalen, Diane,
 Painting the American
heartland in watercolor *23⁹⁹*

	DATE DUE	
MAY - 5 '99	FEB 1 1 2004	
MR -8 '99	MAR 2 2004	
AUG 2 9 '00	APR 2 0 2004	
MY -8 '02	OCT 5 2004	
SE 21 '02	DEC 2 7 2004	
OC 23 '02	JAN 2 4 2005	
JA 02 '03	AUG 1 5 2005	
FO. 02 V	OCT 2 1 2005	
JA 20 '03		
FE 7 '03		
DEC 2		

Basalt Regional Library
99 Midland Avenue
Basalt CO 81621
927-4311

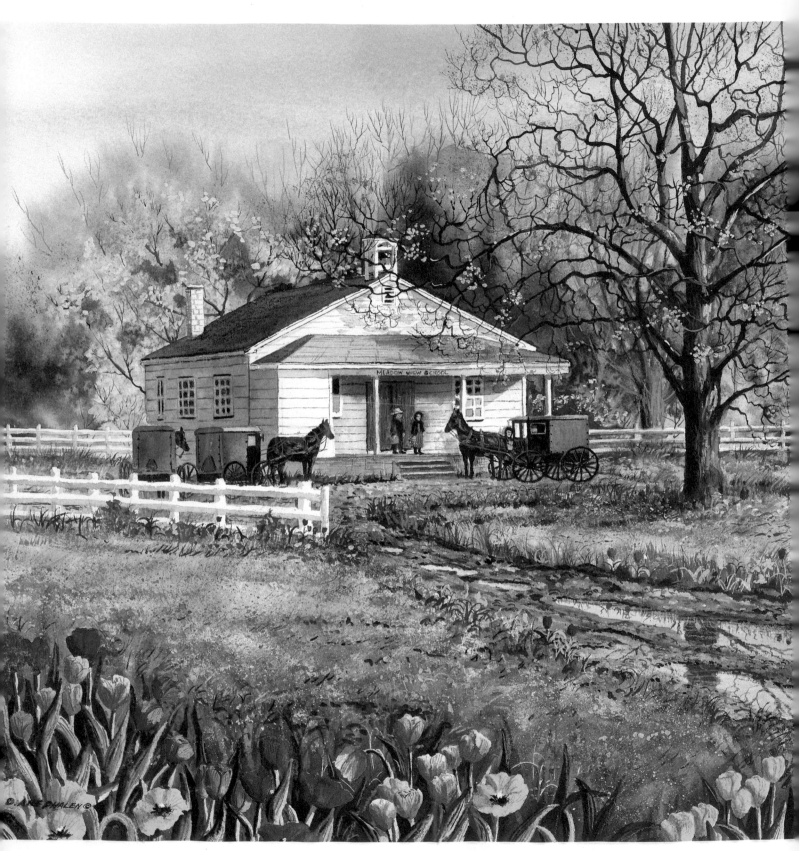

SCHOOL'S OUT!
15″ × 22″ (38cm × 56cm)

PAINTING THE

American Heartland

IN WATERCOLOR

DIANE PHALEN

NORTH LIGHT BOOKS
CINCINNATI, OHIO

Basalt Regional Library
99 Midland Avenue
Basalt CO 81621

ABOUT THE AUTHOR

Diane Beginnes-Phalen was born and raised in Bethlehem, Pennsylvania. Her love of art and nature began in her early childhood years: She spent many hours every day sketching in the beautiful Pennsylvania countryside that surrounded her home. Although she currently resides near Banks, Oregon, Diane returns often to her native state to visit family and recall favorite childhood memories. She spends much of that time traveling the back roads of Pennsylvania, including the rustic Amish settlements of Lancaster County. It is here she finds the picturesque barns, covered bridges, country stores and beautiful quilts she loves to paint.

Diane's goal is to convey to the viewers and collectors of her paintings the smell of flowers, the feeling of a warm summer day or cooling breeze, the mood of an autumn sky or winter sunset, and the peace and contentment of nature and her Pennsylvania heritage.

Diane is best known for her continuing American Quilt series, of which prints, posters, notecards and gift items are distributed worldwide.

Painting the American Heartland in Watercolor. Copyright © 1997 by Diane Beginnes-Phalen. Printed and bound in Singapore. All rights reserved. No part of this book may be reproduced in any form or by any electronic or mechanical means including information storage and retrieval systems without permission in writing from the publisher, except by a reviewer, who may quote brief passages in a review. Published by North Light Books, an imprint of F&W Publications, Inc., 1507 Dana Avenue, Cincinnati, Ohio 45207. (800) 289-0963. First edition.

Other fine North Light Books are available from your local bookstore, art supply store or direct from the publisher.

01 00 99 98 97 5 4 3 2 1

Library of Congress Cataloging-in-Publication Data

Beginnes-Phalen, Diane.
 Painting the American heartland in watercolor / Diane Phalen.—1st ed.
 p. cm.
 Includes index.
 ISBN 0-89134-747-X (paperback : alk. paper)
 1. Watercolor painting—Technique. I. Title.
ND2240.B44 1997
751.42′2—dc21 96-29887
 CIP

Edited by Jennifer Long and Kathy Kipp
Production edited by Amy Jeynes
Designed by Brian Roeth

North Light Books are available for sales promotions, premiums and fund-raising use. Special editions or book excerpts can also be created to specification. For details, contact: Special Sales Manager, F&W Publications, 1507 Dana Avenue, Cincinnati, Ohio 45207.

ACKNOWLEDGMENTS

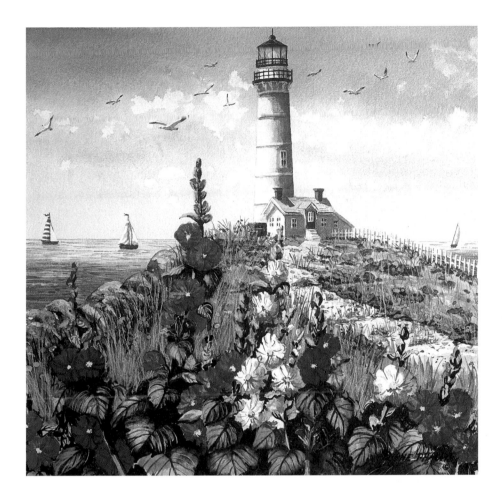

Since the first day I became interested in art, I have been fortunate to have love and encouragement from many sources, all of whom I owe a debt of gratitude.

Thank you to my wonderful parents, John and Arlene Beginnes, for always encouraging my love of the outdoors and my artistic endeavors—and especially for their love. Also, to my three sisters—Linda, Anne and especially Mary Woytko—for all the wonderful trips we took together into the Pennsylvania countryside searching for the treasures that led to so many of the watercolors created for this book.

Thank you to my husband Mike for all the support, love and encouragement in every step of my art career. You've made it possible for me to follow my chosen path by being the business mind behind my art.

Many thanks to my staff—Michelle, Sharon and Dee. Special thanks to Michelle Sexton for keeping me organized and for her enthusiasm and words of encouragement. Also to Sharon Meeuwsen for all her invaluable help and insight on this project.

Appreciation to the special people at North Light Books. A very special thank you to Greg Albert for giving me the opportunity to do this book. Also, special thanks to Kathy Kipp and Jennifer Long for all their encouragement and guidance each step of the way.

Of course, a final thanks to all the wonderful collectors of my art—because of your enthusiasm and appreciation I will always be inspired to paint the next watercolor.

TABLE OF CONTENTS

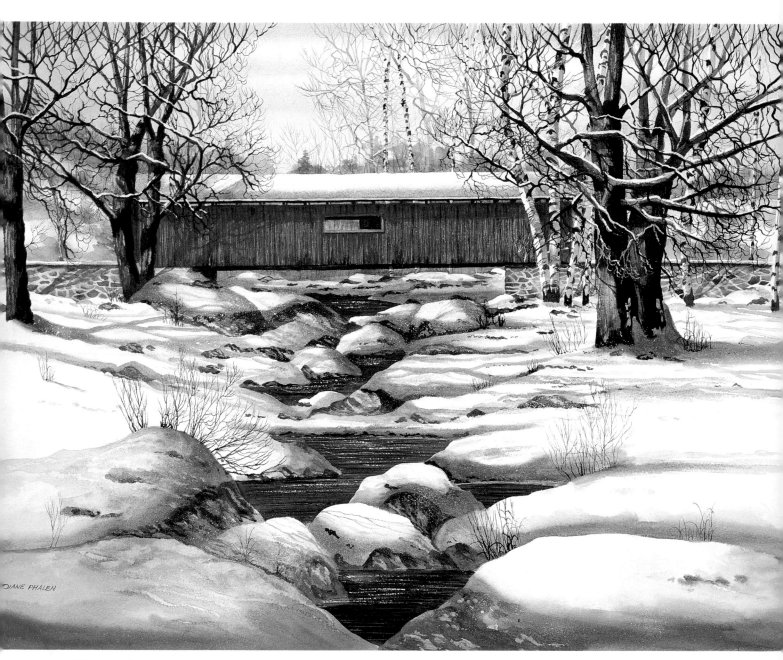

WINTER SERENITY

22″ × 30″ (56cm × 76cm)

INTRODUCTION

From the first day I discovered watercolor, I knew this would be my lifetime challenge. Each and every painting excites me with the new surprises and techniques I learn. You'll learn a few of your own while completing the step-by-step instructions in this book. The projects cover basic watercolor techniques, as well as a few original techniques I've learned throughout my years of painting watercolors. While you are first learning or applying new techniques, you may want to use a separate sheet of watercolor paper to practice on before trying it on your actual watercolor paper.

Each project includes an outline drawing for you to photocopy and enlarge or to trace over and transfer to your watercolor paper. Each step-by-step project shows you how I did the painting. Give all the techniques a try, and copy the paintings as I have done them if you wish. If in your painting you find something that works better for you, use it! This will be your own personal style emerging. You'll develop your own method of expression, and it will be different from anyone else's, as in your signature and handwriting style.

As you become comfortable copying the different techniques and methods of painting and the step-by-step instruction outlined in the projects, use the techniques and skills you have acquired to paint your own emotions and responses to what surrounds you.

Travel a back road, take photographs, make sketches and create a painting from your own impressions. If you live in a city, apply the same techniques to the buildings and people that surround you. Carry a sketch book with you at all times because you never know when inspiration will tap you on the shoulder. Most importantly, have fun!

Getting Started

This section covers all the supplies you'll need to paint the projects in this book, along with some tips on how to use them. It will also introduce you to some of my favorite basic painting techniques. Once you've read through these pages and gathered your materials, you're ready to start painting!

Paints

It is very important to use **good quality artist's paint**—avoid student grade paints as you may be disappointed with the results. My favorite brand of paint is Daniel Smith Extra Fine Watercolors. Their lightfastness and the broad range of colors are exceptional.

In addition, I still use a few Winsor and Newton watercolors such as Sepia, Winsor Yellow, Winsor Blue and Naples Yellow. I do not limit my palette—nature comes in a multitude of colors, values and richnesses. If you can't afford to buy a full palette, start out with a few basic colors and add to your collection gradually.

I like to use my watercolors directly from the tube. I feel the tube colors are richer than dry blocks of paint. Scrubbing over the dry watercolors can also be hard on my good brushes. Tube colors are easier to work with, and the colors can be mixed directly from the tubes like oil paint.

Occasionally, I like to use **gouache** for highlights in my watercolors. Gouache is opaque watercolor that can be applied thickly, or thinned just like regular watercolors. It is useful for its covering power, as well as its ability to be applied in fine detail. My preferred gouache is Winsor and Newton. Occasionally I mix Winsor and Newton Permanent White with a transparent watercolor.

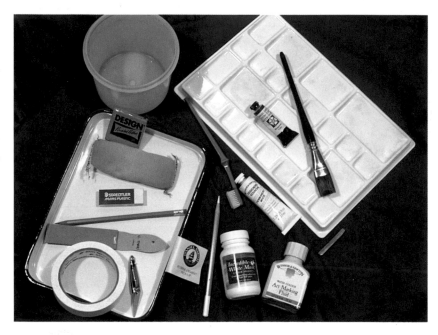

For an additional "glow" to my watercolors, I like to add **fluorescent gouache** to paintings when I am glazing. Although fluorescents are too bright by themselves—demanding the viewer's attention like a flashing light—mixing a touch of fluorescent gouache with another color or using it under a glaze of other colors works well.

Winsor and Newton fluorescents are my favorite—they have good color saturation and a higher standard of permanence. To give these pigments additional staying power, I add **matte picture varnish with UV absorber** in small brushstrokes over any strong fluorescent colors.

It's difficult to tell by a single stroke of color just what your color palette can do. Experiment before you do each project by applying different colors on a scrap piece of watercolor paper (I use the backs of watercolor paintings that didn't turn out how I had envisioned them). Mix your yellows with blues and greens. Mix blues with reds. Experiment with some of the color combinations that I use frequently, such as Permanent Rose and Cobalt Blue for a brilliant purple, or Winsor Yellow and Cobalt Blue for a brilliant green. Have *fun* before you get serious! You'll know more about how your colors work, and be more confident in your painting.

Watercolor Pencils

I use these like gouache to suggest a highlight, soften a color or add additional colors and textures. I like to apply them dry and sometimes soften the lines with a brush of water.

Water Containers

I use one container for washing out brushes as I work. The other container contains clear water used to wet the paper and for softening colors.

Brushes

It's better to have a few good brushes than lots of inexpensive supplies that won't give you the results you desire. When I first started painting, I used to use my dad's painting brushes (house painting, mind you)—of course, you can imagine the results!

My preferred brushes are Daniel Smith **Kolinsky sable round** or Daniel Smith **red sable round**. I find these to be of excellent quality. When choosing your brushes, remember that the belly of the brush must hold your paint well and the end must taper and point beautifully.

It's also good to have **several round brushes** ranging from no. 0 to no. 6. Also, I highly recommend getting **several flat brushes** for applying larger wash areas, preferably a 1¼ inch or 2-inch wash brush as well as a ½-inch or ¾-inch flat wash brush. Again, Daniel Smith offers a good selection of wash brushes. A stiff-haired **bristle brush** also comes in handy for special techniques like dry brushing.

Because both the Kolinsky and red sable brushes are expensive, you may wish to get a small no. 0 or no. 1 to start with. There are also good, less expensive brushes—just be sure the round brush retains a good point and the hairs do not separate when wet. Also make sure the body or belly of the brush holds a good amount of color.

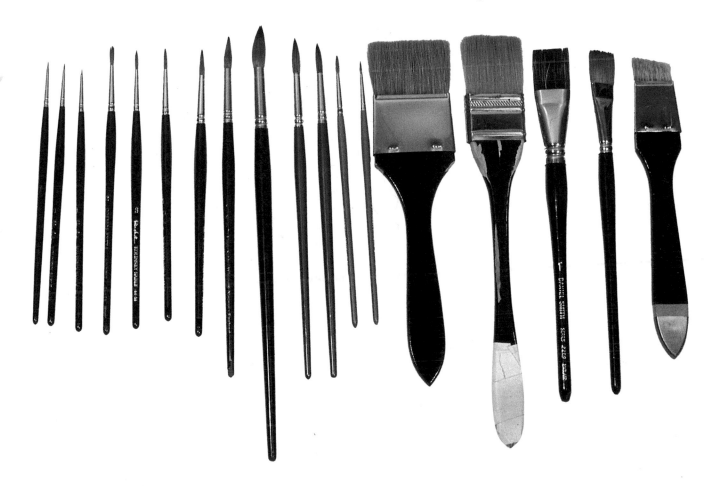

On the left is a selection of round and detail brushes; on the right various flat wash brushes.

Papers

I begin each painting by working out my drawing in a **soft lead pencil**, such as a 2B, on **layout or tracing paper** (preferably Strathmore 11″ × 16″ tracing paper). Make sure the pencil lines of your drawing are dark enough that you can see them when transferring. When the drawing is complete, rub **graphite** over the back of the tracing paper, covering all areas to be transferred. Tape the drawing graphite side down to your watercolor paper, then trace back over the pencil lines. When the drawing is transferred, lift the tracing paper up carefully and go over any missing or light pencil lines with an **HB pencil** so the initial watercolor washes won't erase your lines.

An alternative to rubbing the back of your sketch with graphite is to lay a separate sheet of **graphite paper** under your drawing. This sheet may then be used for several transfers.

For the painting surface, my preference is **300 lb. Arches cold-pressed watercolor paper** because of its ability to retain water washes without buckling. (Cold-pressed means the paper is rougher in texture; hot-pressed papers are smoother.) Thinner, lesser quality papers have to be stretched first. Also, the 300 lb. paper is better able to take multiple techniques such as

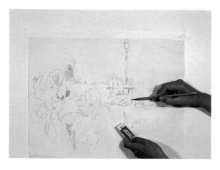

1. Work out the drawing on layout paper.

2. Cover the back with graphite.

3. Place layout paper on top of a sheet of drawing paper and sketch the lines from underneath, transferring the final drawing.

4. Check that all lines have transferred to your watercolor paper.

lifting, scraping and masking which thinner, cheaper papers can't withstand.

Before painting, tape down your watercolor sheet on all four sides to a **drawing board** or **Masonite** (or any sturdy surface) with **artist's white tape**. I don't use masking tape as it doesn't stick as well and may come up during your initial washes.

Erasers

Two favorites of mine are kneaded rubber and Staedtler Mars plastic. You can also use drafting powder to remove any graphite that darkens the paper. This procedure will leave your pencil lines intact.

Palette Knife and Nail File

In 1986 I was fortunate enough to take a watercolor workshop from one of my favorite watercolorists, Zoltan Szabo. It was then I learned to use the palette knife with my watercolors. I have used it ever since, and I love the special effects it adds to my paintings. Practice some of the techniques I have outlined until you are comfortable with the palette knife.

As you can see, my palette knife is well-worn since I have been using it ever since that first workshop. The shiny and polished surface of a new blade will not hold the watercolor, letting it bend and roll off; the blade needs to be specially prepared. First, sandpaper the finish on the knife blade to remove some of the lacquer. To remove all of the coating, the blade must next be soaked in vinegar for a few hours. The blade will emerge looking corroded. Wipe it off with a powdered cleanser and your blade is now ready to accept watercolor paint.

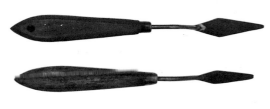

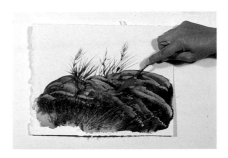

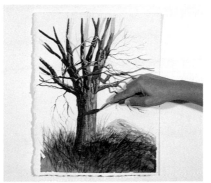

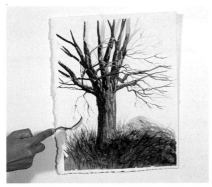

ROCKS AND GRASS

To create rocks, use various shades of Sepia and Burnt Sienna in a thick consistency on a wet brush, and apply on a dry surface. Add Sap Green for a mossy look. As soon as the colors are applied to the paper, take the blade of the palette knife and scrape the lighter edges of the rocks to show both light and texture. The tip of your palette knife is also a good tool to show grass texture. Use the tip to scrape out texture while the area of color is wet.

BARK

Use the same palette knife technique for creating light areas of bark on trees by scraping out texture. In addition, use the tip of the knife to make lines in the shadow areas of the bark.

BRANCHES

Use the palette knife as you would a paintbrush to create branches. Dip your knife directly into a thin consistency of Sepia, or load the blade with a paintbrush. Use the tip of your palette knife to draw the branches and blades of grass.

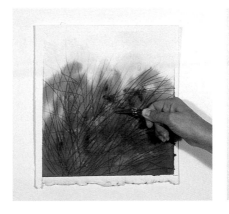

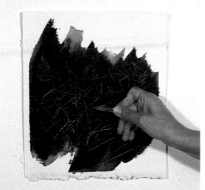

CREATING LIGHT AND DARK STROKES

You can use the point of a nail file to get the same effect as a palette knife. When the paper is very wet, the knife or nail file will scratch out dark strokes (left). When most of the moisture is gone from the paper, the effect will be lighter strokes and lines (right).

Masking Fluid

Masking fluid—which is like liquid latex—forms a protective film when dry, saving areas you wish to remain unchanged by further washes or retaining the white of the paper surface to serve as a highlight.

Masking fluid is sold under different trade names including Liquid Friskit, Miskit and Maskoid, to name a few. My personal favorite is Incredible White Mask. I like it because it is nonstaining to the paper and good for protecting whites (snow areas for example). I also like Winsor and Newton Regular Art Masking Fluid if I want a slight tint to indicate where I have applied the mask, especially if I'm using a lot of masking in areas with grasses, leaves, etc. and don't want to overlap the mask.

To mix the masking fluid, gently shake the bottle from side to side. The first time you open the bottle you may need to stir it with a clean brush handle or wooden stirring stick. When masking, the use of good tools and good paper is a must. I use some of my older brushes that still retain a good point, or **synthetic acrylic brushes**, usually a no. 0, no. 2 or no. 6. You can also use ink dipping pens or calligraphy pens with steel points from which the latex will clean off with water. To protect a brush from the damaging effects of latex, apply **soap** to the brush hairs prior to dipping them in masking fluid. Immediately after use, rinse your brush in soapy warm water to remove all the latex.

I recommend a heavyweight paper such as 300 lb. Arches whenever masking fluid is being used. If your paper is too soft, layers of paper may pull up when you remove the masking fluid. To prevent tearing or sticking, make sure the masking fluid is completely dry before applying watercolor to your paper. By the same token, don't apply masking fluid to or remove it from wet paper, as you may end up with smudges, tears or bleed-throughs.

Make sure the masking fluid is properly mixed and flows from your brush without bubbles, which will leave holes in the latex and allow color to seep through the film. Apply the fluid in a thin, even coat. Do not speed up the drying process with a hair dryer. The heat from the dryer will make the latex more difficult to remove.

When dry, use a **rubber cement pick-up** to remove the masking fluid. First remove any color on top of the latex with a **wet tissue or cotton swab** so it will not be rubbed into the protected areas. You can also remove masking fluid by gently applying **masking tape** on top of the latex. When the tape is removed, the masking fluid will lift off with it.

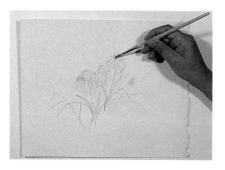

Apply the masking fluid to areas where you wish to retain the white of the paper.

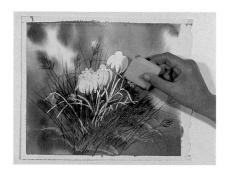

When the masked area is dry, you can paint over and around it. When the paper is thoroughly dry again, gently remove the mask.

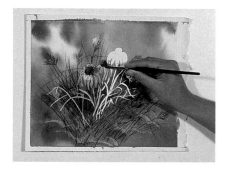

The white areas can now be painted, or left white to serve as highlights.

Painting Techniques

Everyone develops their own unique style of painting. It's like handwriting; your personal touch develops with time and practice. Following are some of the basic techniques I employ in my watercolors.

FLAT WASH

One of the basic washes you can start with when applying initial washes in the background area with transparent watercolor is a flat wash. It is basically one color applied evenly to dry or slightly damp paper. It is important to apply the first stroke starting at the top of the painting, then immediately follow the second stroke of paint below, slightly overlapping the first stroke.

GRADED WASH

A graded wash is my favorite for sky areas. The paper can be dampened with clear water first, or the wash can be applied to dry paper. This wash is similar to the flat wash, except here the darkest color is applied at the top of your painting. Adding water to each subsequent brush stroke dilutes the initial color, eventually ending with clear water. The graded wash is also good when painting water—simply reverse the technique and begin the darkest wash at the bottom of the page, moving up to the horizon line with more diluted washes.

WET-IN-WET WASH

For this technique, apply clear water to your paper to wet it. Color then applied to the paper can be spread around to different areas. I like this wash for skies that have clouds and fir trees or foliage in the distant background.

Any of these wash techniques can be made lighter by adding more water to your brush or paper. A darker or heavier wash is made by using less water and more paint on your brush and/or paper. A "wet wash" is simply one in which the brush is saturated with water and paint.

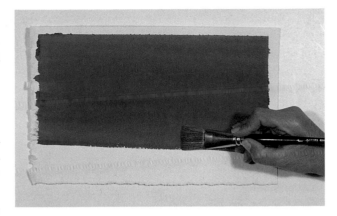

Flat wash.

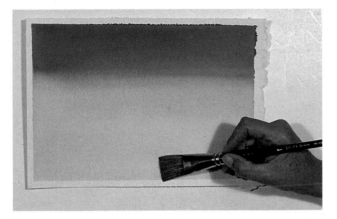

Graded wash.

Wet-in-wet wash.

GLAZING

Glazing is a technique I use often. My initial color is usually too pale for my taste. When I add layers of color on top of each other, the color becomes vibrant and seems to glow. The most important part of this technique is to allow each wash to dry before applying the next wash.

FLOATING OR BLENDING WASH

In this technique, the colors are actually allowed to blend into the wet areas of the paper. To float colors, wet the entire area of the object. Then, using a brush with very little water, dry-brush the first or lightest color onto the wet area. Next, apply your first shadow color to the shadow or darker area, and if needed, a second even darker shadow color, allowing the colors to float and mingle on the wet paper.

For a more controlled blending of colors, leave the paper dry and use a wet brush of color. Then, starting in the shadow area, apply color, and immediately use a brush of clear water to go along the edge of the applied color area. The color will blend and melt toward the light side of the area, creating a soft gradation from dark to light.

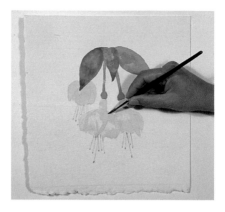

Put initial color down in a light wash. Usually I start out light, but sometimes I like to put down a fluorescent gouache for that extra-transparent glow.

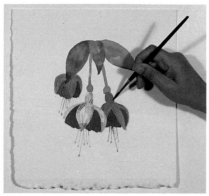

Put the next color down, usually the darker value or pigment color over a staining color. Or use a darker value of the same color to build up the values slowly.

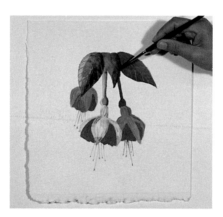

Layer lightly and build your color gradually, always allowing each wash to dry completely between layers.

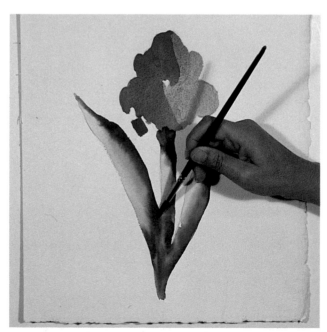

Add shadows and highlights by floating on the colors.

DRY-BRUSHING

I often use the term "dry-brush" in my instructions. A dry-brush is not a brush without water—watercolor paint needs water to apply itself to the paper. A dry-brush stroke is made when your brush is slightly moist and your paper dry—simply blot extra moisture from your brush on a tissue before making the stroke. You don't need to use a heavy concentration of paint unless the directions call for a heavier dry-brush. Using a flat or bristle brush, hold the brush against the paper and drag it across. This technique works best on rougher paper.

BLOTTING

Use crumpled **facial tissues** to blot out areas in the sky to suggest clouds. Tissues can also be used to blot color in other areas of your painting such as the foliage, or for lifting color out that is applied too darkly.

SPATTERING

Run your thumb or a palette knife toward you over the bristles of an **old toothbrush** loaded with thinned paint. A spattering of fine speckles of white gouache suggests falling snow; other colors suggest leaves, flowers and additional texture. Using more water will create larger, less defined splotches which will spread and fade as they dry—spattering on wet paper will heighten this effect. Spattering with less water on dry paper will create a fine mist of droplets. Experiment with this technique on scrap paper, varying the distance you hold the toothbrush from the paper, until you achieve the desired effect.

A FEW FINAL NOTES

My method of painting can be summed up as follows: I always apply the initial washes in the background first, with wet washes of transparent watercolor using the wash techniques described. As I move forward from the background in my paintings, I continue with washes or glazes, letting each color dry before laying down the next color.

Gouache can be used to create details in a painting. Keep it thinned with water. It's perfect for adding highlights and detail in grasses, petals and foliage.

Once everything has dried, I carefully use **sandpaper** or quick washes of clear water to soften some edges. Keep a tissue handy to blot any areas that blend too much with other colors.

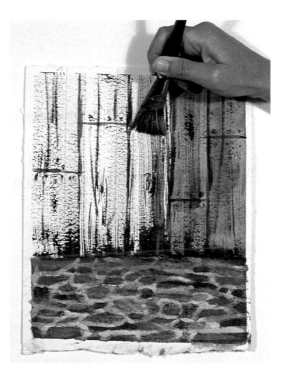

Use the dry-brush technique to create texture.

Facial tissues come in handy for creating texture and blotting areas where too much paint has pooled.

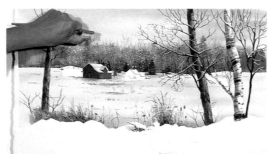

Use an old toothbrush to spatter random droplets of paint.

Water Pump and Pansies

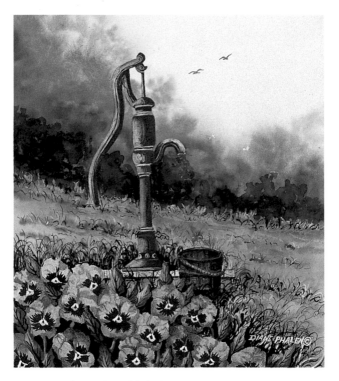

*I love the old-fashioned water pumps
you see throughout my native Pennsylvania.
They are still in use on Amish farms, and are
always surrounded by beautiful flowers.*

MATERIALS

- Tracing paper, pencil, eraser
- 15″ × 20″ Arches 300 lb. cold-pressed watercolor paper
- Artist's tape
- Masking fluid
- Rubber cement pick-up
- Tissues

BRUSHES
- no. 1 round
- no. 2 round
- no. 6 round
- no. 6 flat
- 1-inch flat
- 2-inch flat

PALETTE

Naples Yellow	New Gamboge	Burnt Sienna	Sepia	Cerulean Blue	Cobalt Blue

Ultramarine Blue	Carbazole Violet	Cobalt Violet	Sap Green	Phthalo Green	Payne's Gray

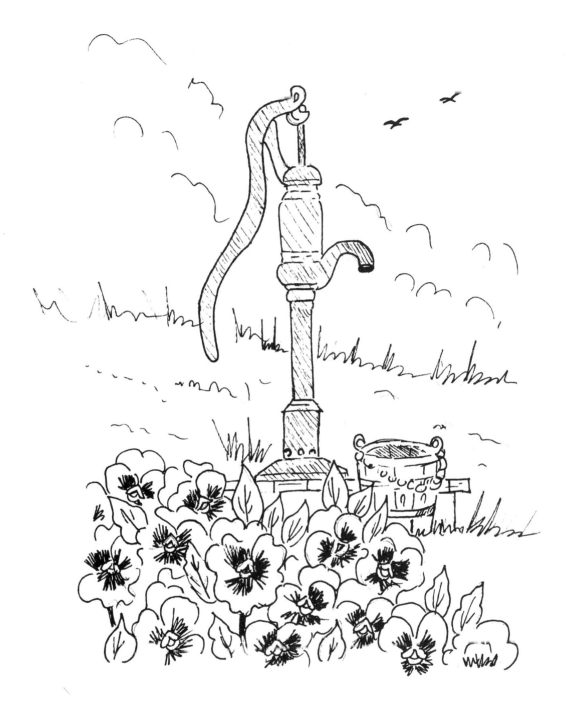

Step One

Tape all four sides of the watercolor paper to your drawing board with artist's white tape. Transfer the drawing to your watercolor paper.

TRANSFERRING A SKETCH

You can make your own transfer paper by rubbing graphite over the entire surface of another sheet of layout paper, then laying it graphite side down over your watercolor paper. Place the sketch on top of the transfer paper and secure both papers at the corners with artist's tape. Trace over the sketch with a pencil. After removing the transfer paper and sketch, you can erase any smudges on the watercolor paper with a kneaded eraser or drafting powder.

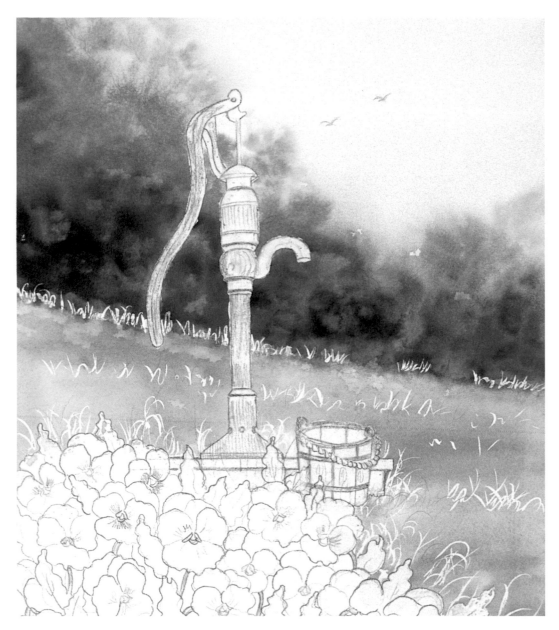

Step Two

Apply masking fluid to the middle grasses, water pump and bucket, and outline the tops and centers of the pansies. When the mask is dry, wet the sky area with clear water. While the paper is very shiny, lay in the sky wash with Naples Yellow. Always keep a tissue handy to mop up any water that may trickle down past the background. Immediately lay in the tree area with a mixture of Cerulean Blue and Sap Green. Add Ultramarine Blue to the previous mix to darken the bushes. As the painting dries and loses its shine, darken the lower bushes with Cerulean Blue, Sap Green and Ultramarine Blue. The middle grasses may be done at the same time using a lighter mixture of Cerulean Blue and Sap Green.

MASKING FLUID

Masking fluid is used to protect areas of the painting from the initial color washes, keeping the original white of the paper. When the mask is removed, these areas can be painted with lighter washes, or left as white highlights. Before applying masking fluid with a regular watercolor brush, rub a little liquid soap into the brush hairs to protect them from the fluid. Always wash the brush immediately after applying the mask.

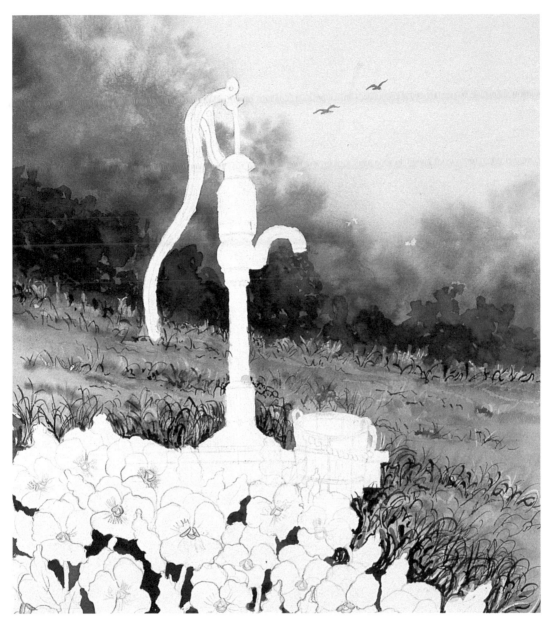

Step Three

When the background is dry, remove all of the masking fluid except that on the flower centers. It is important that the paper be completely dry before you remove the mask because it may tear, or the wash may smudge into the white areas. Using a mix of Sap Green and New Gamboge, go over the grass area in the middle ground. Keep this rather wet, trying to work around the grasses that were masked. Add a mix of Sap Green and Ultramarine Blue to some areas of the grass and along the tree line to create more contrast. Detail the birds with Cerulean Blue on a no. 1 brush. As the grass dries, suggest individual blades by drybrushing a mixture of Ultramarine Blue and Phthalo Green with a no. 2 brush. Use a darker mix of Ultramarine Blue and Phthalo Green between the leaves at the bottom of the pansies.

DRYBRUSHING

To paint fine details and small areas, you don't want your brush to be overflowing with paint. After loading it with paint, stroke the hairs on a tissue to remove excess moisture. This will allow you to apply paint to a specific detail without it bleeding into surrounding areas.

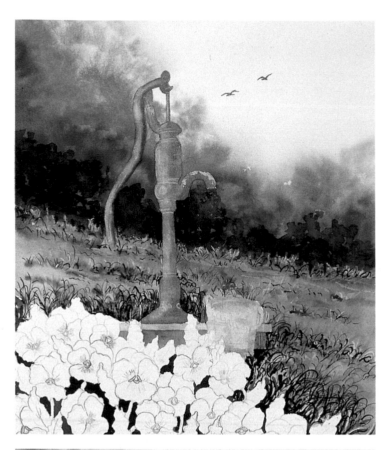

Step Four

Lay in a very wet wash of Cerulean Blue and Sepia for the background of the water pump. The pigments of these two colors will not mix well when they dry, resulting in a grainy effect that will suggest a metal texture. Also lay some loose washes of Cerulean Blue and Sepia over the bucket for a similar effect.

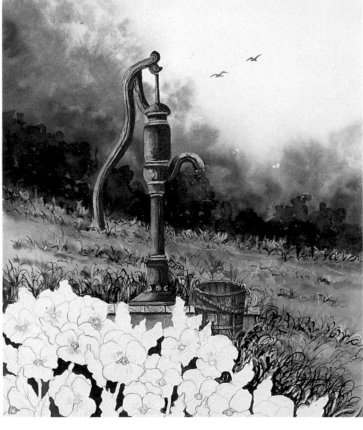

Step Five

Add a shadow of Payne's Gray, Cerulean Blue and Sepia to the right side of the pump. Add the same color to the bucket. When dry, use Sepia on a no. 2 brush to add details to the bucket.

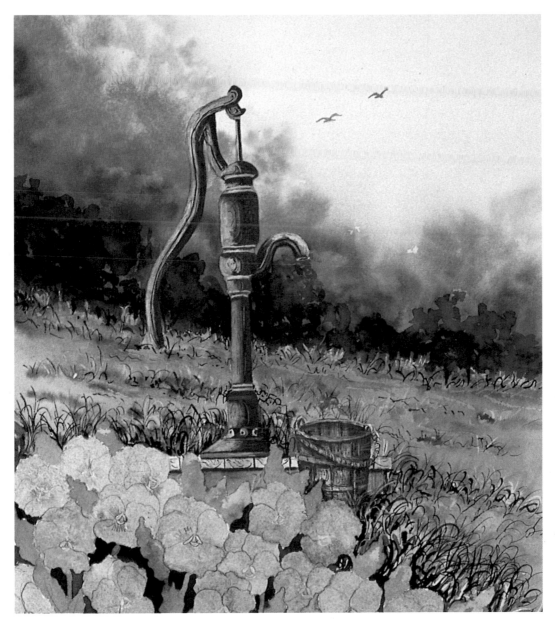

Step Six

Do the initial color washes for the pansies with Cobalt
Violet and for the leaves with Sap Green.

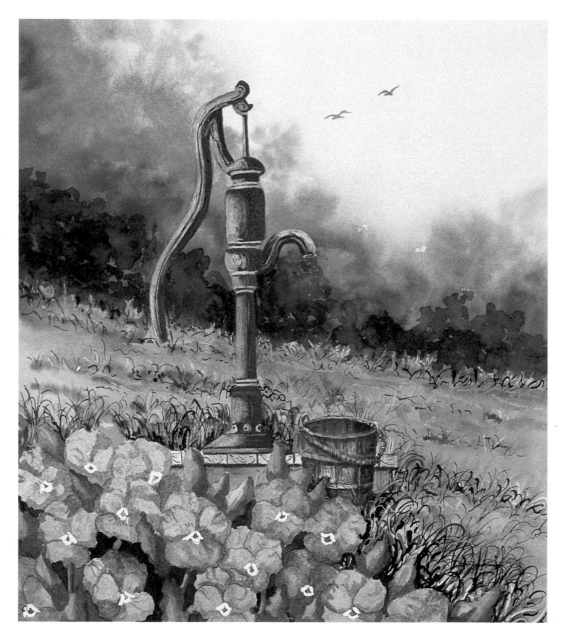

Step Seven

Add shadows to the pansies using Cobalt Blue on a wet brush. Add Cobalt Blue shadows to the leaves and shadow areas of the pail. When the pansies are completely dry, remove the masking fluid from their centers.

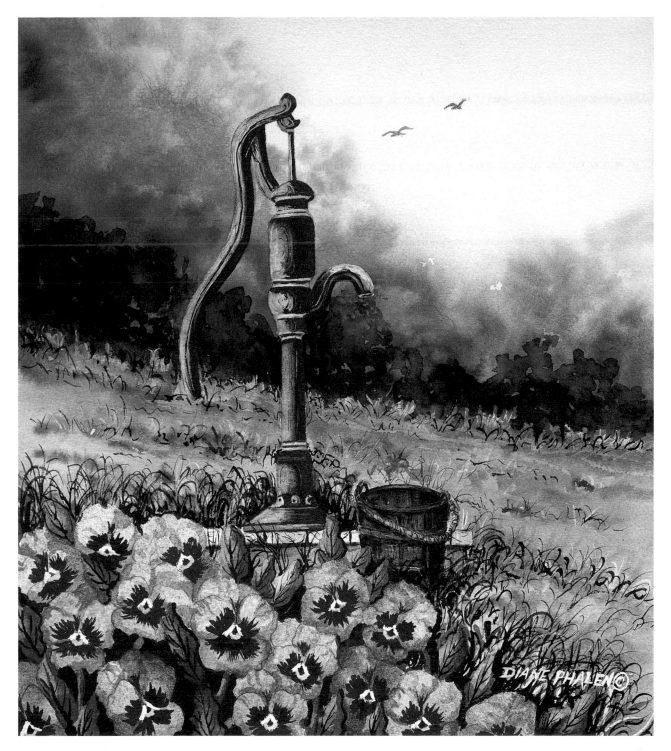

Step Eight

Detail the veins in the pansies with Carbazole Violet and Cobalt Violet on a no. 2 brush. Mix Ultramarine Blue and Phthalo Green to detail the veins in the leaves and add more detail to the grass along the pump. Use New Gamboge to fill in the pansy centers. Add some Burnt Sienna to the pail to complete the painting.

Fuchsia and Hummingbird

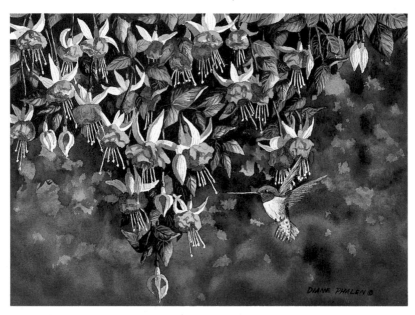

*I grow beautiful hanging fuchsia plants outside my studio window
during the summer months. If I pause in my painting and watch,
I sometimes see tiny hummingbirds flitting among the blossoms.
I am always sad to see them leave on their winter journey south.*

MATERIALS

- Tracing paper, pencil, eraser
- 15″×20″ Arches 300 lb. cold-pressed watercolor paper
- Artist's tape
- Masking fluid
- Rubber cement pick-up
- Tissues

BRUSHES
- no. 0 round
- no. 2 round
- no. 6 round
- 1½-inch flat

PALETTE

| New Gamboge | Yellow Ochre | Cadmium Red | Permanent Rose | Rose Madder (optional) |

| Cobalt Blue | Sap Green | Ultramarine Turquoise | Payne's Gray |

| Fluorescent Yellow gouache (optional) | Fluorescent Magenta gouache (optional) | Fluorescent Red gouache (optional) |

Step One

Transfer the sketch to your watercolor paper.

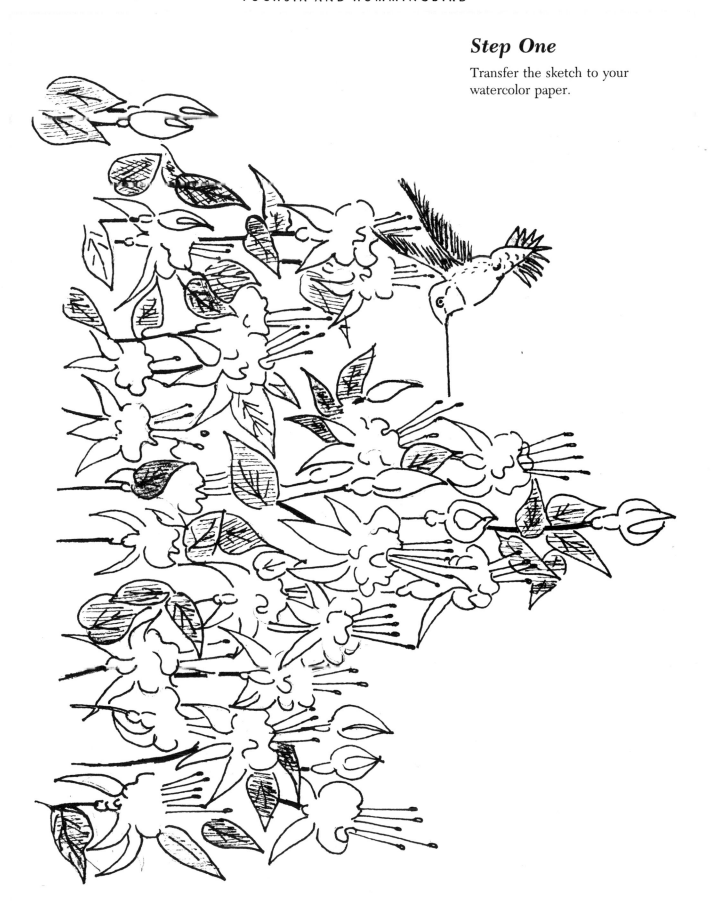

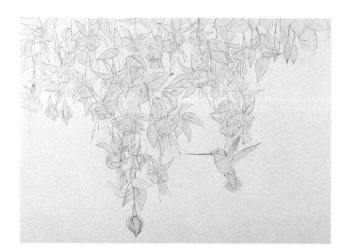

Step Two

Mask the entire drawing area. Since you want to use a very wet application for the first background wash, it is easier to protect the fuchsia and hummingbird rather than trying to work around individual blossoms and leaves.

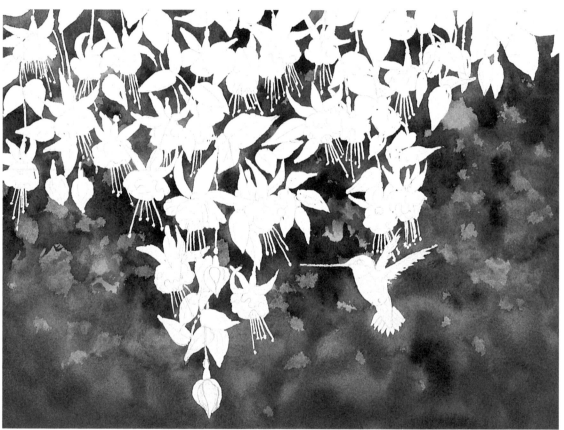

Step Three

When the masking fluid is entirely dry, lay in a very wet wash of Ultramarine Turquoise and Sap Green with a 1½-inch wash brush. While the wash is wet but starting to lose its shine, randomly dab the paint with a crumpled tissue to suggest lighter areas among the foliage behind the fuchsia plant. The Sap Green will stain the paper so that it will be lighter green underneath. Let the entire painting dry and then remove all the masking fluid.

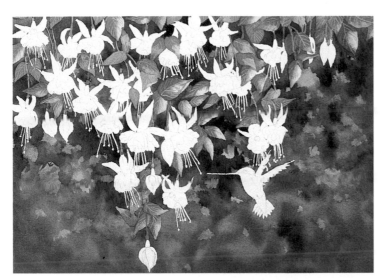

Step Four

Stroke a mixture of Sap Green and New Gamboge on the shadow side of the leaf. With a no. 6 round brush dipped in clear water, blend the color on the sunlit side of the leaf. While the leaf is still wet, use a white watercolor pencil to suggest veins in the leaf pattern. This establishes veins and light areas in the leaves.

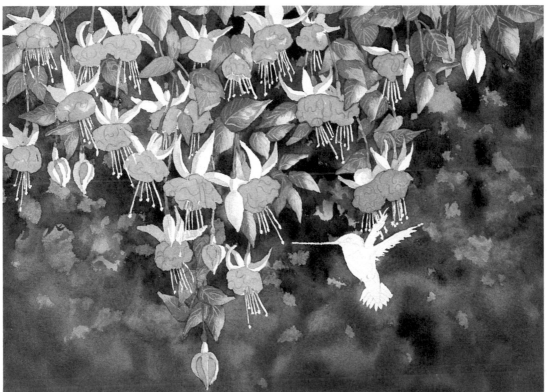

Step Five

Lay in the initial wash of Permanent Rose for the sunlit petals of the fuchsia blossoms. Using a no. 6 round brush, lay in light washes of Cobalt Blue for the shadow areas of the white petals and stamens.

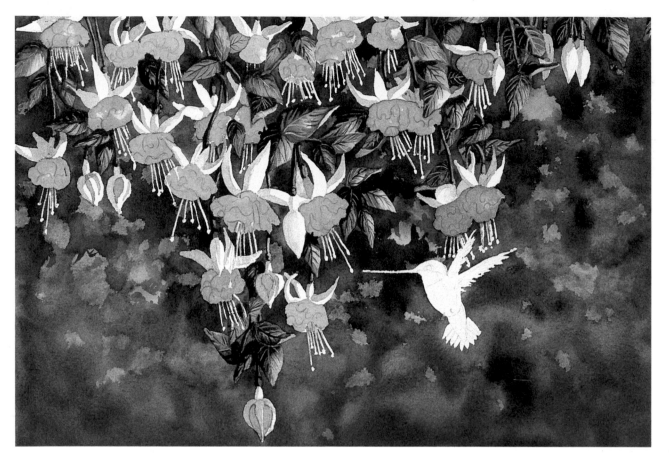

Step Six

Show the shadows of leaves with wet blending washes of Ultramarine Turquoise. Suggest dark veins in the leaves with a no. 0 round detail brush.

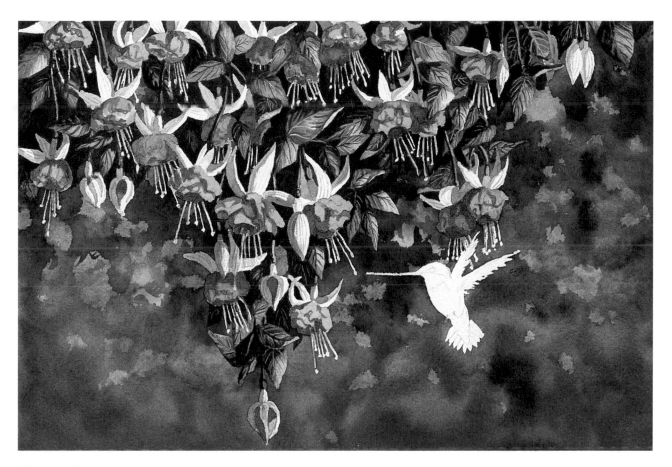

Step Seven

Use a dry brush of Permanent Rose or Rose Madder for the shadow areas of the ruffles and stamens in the fuchsia blossoms. Add Cobalt Blue to the fuchsia shadows and the crevices of the shadows in the ruffles. This, combined with the earlier washes of Permanent Rose, will give a slight purple hue. Add deeper Cobalt Blue shadows to petals and suggest veins in white petals using a no. 0 round.

For further shadow definition among the background leaves of the fuchsia, work Ultramarine Turquoise among the background leaves and fuchsia with a dry brush. This will not only give better overall contrast, but because of the heavy use of masking fluid, it will make the fuchsia stand out more in the painting without looking as if it were cut out and pasted on.

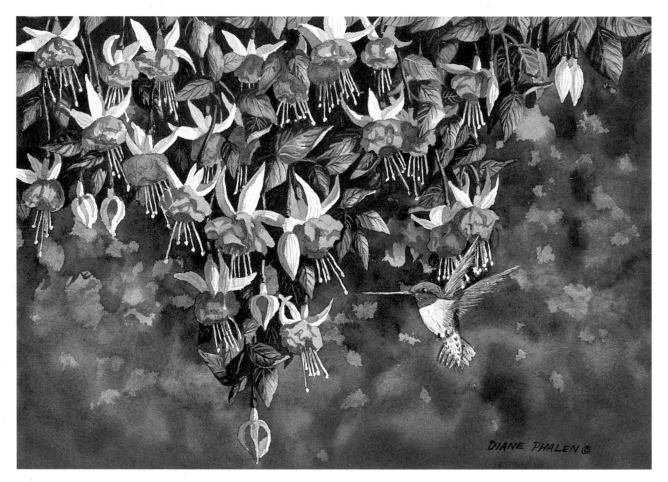

Step Eight

Use a no. 2 round brush and lay in a light Yellow Ochre wash for the hummingbird's breast area. Lay in Payne's Gray washes for the wings, beak, eye, tail feathers and feet. Use Cadmium Red for the throat area.

DIANE PHALEN ©

Fluorescent Glow

This is a fun extra step. I thought I'd introduce it here so you can see the additional glow that fluorescent paint adds. I usually only use fluorescent gouache in underpainting, because its color can sometimes be fugitive. This means it may fade or change over time, or when exposed to bright light.

Use a very wet brush when applying gouache over your initial colors, being careful not to disturb the colors underneath. Use Fluorescent Magenta for the pink in the fuchsia blossoms, Fluorescent Yellow for the leaves and the top of the hummingbird's head, and Fluorescent Red for the hummingbird's throat.

Sometimes even with careful application it is necessary to redefine areas of the painting. Using the colors already on your palette, redo any areas that have lost their detail.

Moonglow, Mount Hood

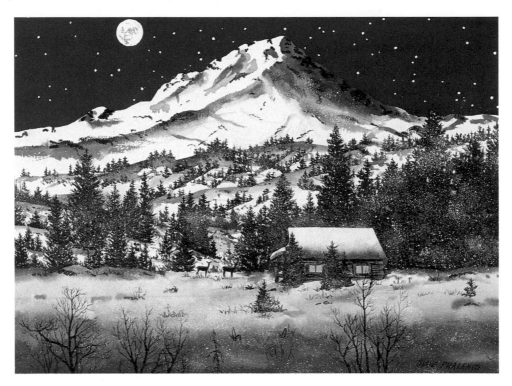

I do a lot of walking and hiking in the snow during the winter months. It is especially beautiful when the full moon, bright in the sky, reflects off the sparkling white of the snow. The nighttime shadows are wonderful to see, as well as the tiny diamonds of light reflecting off the snow's surface.

MATERIALS

- Tracing paper, pencil, eraser
- 17″ × 22″ 300 lb. Arches cold-pressed watercolor paper
- Artist's tape
- Masking fluid
- Rubber cement pick-up
- Tissues
- Toothbrush

BRUSHES
- no. 1 round
- no. 2 round
- no. 6 round
- ½-inch flat
- 1½-inch flat

PALETTE

New Gamboge

Spectrum Yellow

Burnt Sienna

Sepia

Alizarin Crimson

Manganese Blue

Ultramarine Blue

Phthalo Green

Payne's Gray

Moonglow

Permanent White gouache

Step One

Transfer the drawing to your watercolor paper.

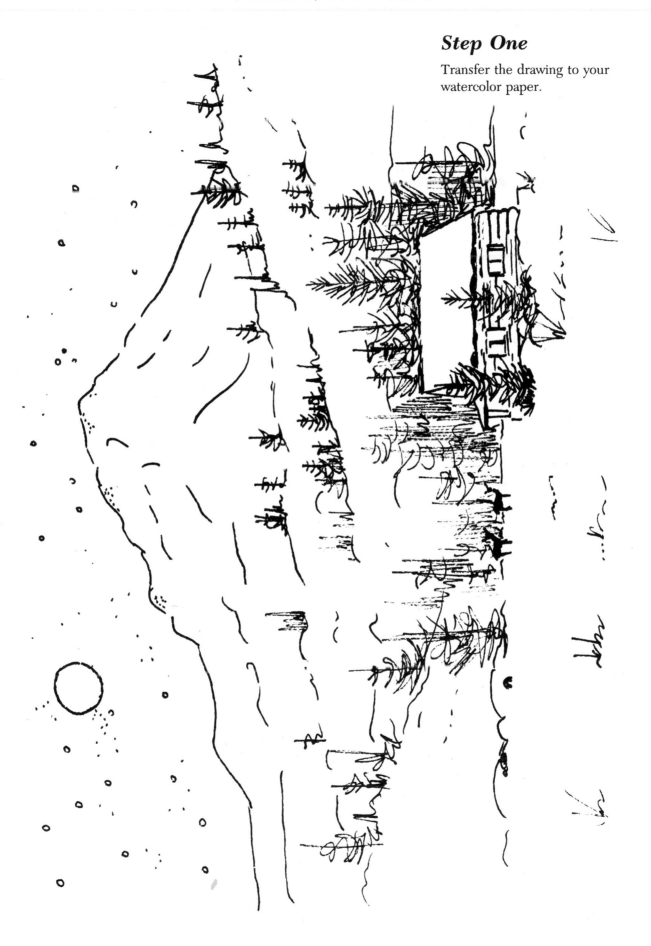

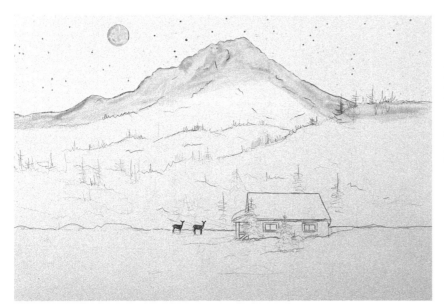

Step Two

Mask out the sky area and mountain peak. Mask the background stars and moon with a no. 1 round detail brush. Rather than masking out the stars, you may prefer to simply paint them in with white gouache after you complete step three.

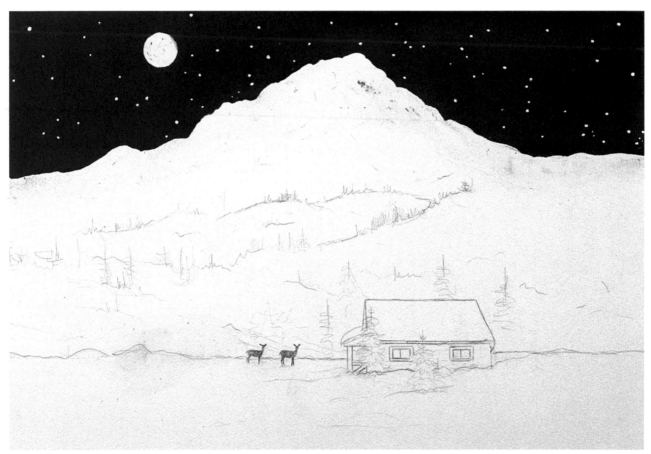

Step Three

Wet the sky with a very wet mixture of Moonglow or a combination of Payne's Gray and Ultramarine Blue. Use a heavy mixture of paint and a 1½-inch wash brush, blending all the way to the mountain peak. When the sky area is completely dry, peel the mask off the stars, moon and mountain peak.

Step Four

Using very wet washes and a no. 6 round wash brush filled with a mixture of Payne's Gray and Ultramarine Blue, begin developing the shadows on the mountain, starting with the right side which is facing away from the moonlight. Continue adding shadow washes over the entire mountain area. Develop the shadow areas as a base even though some of these areas will later be developed further with tree and rock detail.

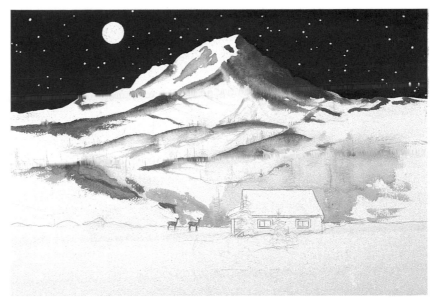

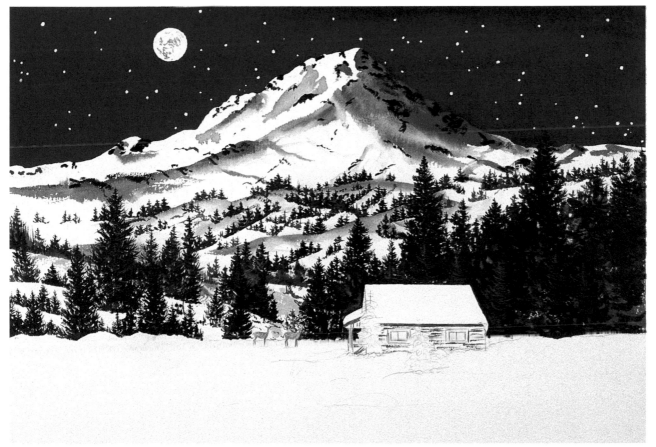

Step Five

Using a very dry no. 2 round brush and Sepia, add the rock texture of the mountain and the wood texture of the log cabin. Add moon crater texture with a dry mixture of Ultramarine Blue and Moonglow or Payne's Gray. Starting with the peak, work your way down the mountain and add the tree line with a mixture of Ultra- marine Blue, Phthalo Green and Sepia. On the trees behind the log cabin, alternate between adding detail with the no. 2 round detail brush and a ½-inch bristle flat for layer areas. Add Spectrum Yellow to the lights in the windows and on the snow under the windows.

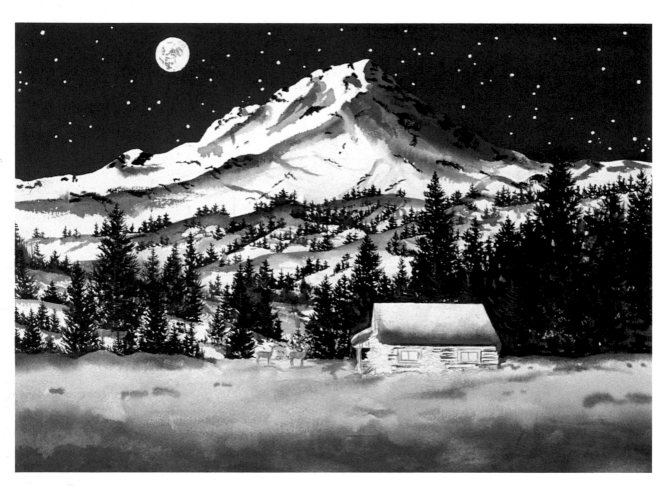

Step Six

Add a very wet wash of Ultramarine Blue, Manganese Blue and Alizarin Crimson to the bottom of the painting. Use a brush dipped in clear water to blend toward the mountain's tree line.

The snow closer to the reflection of the full moon should be whiter. Dab a crumpled tissue randomly through this area to suggest the sparkle of the snow.

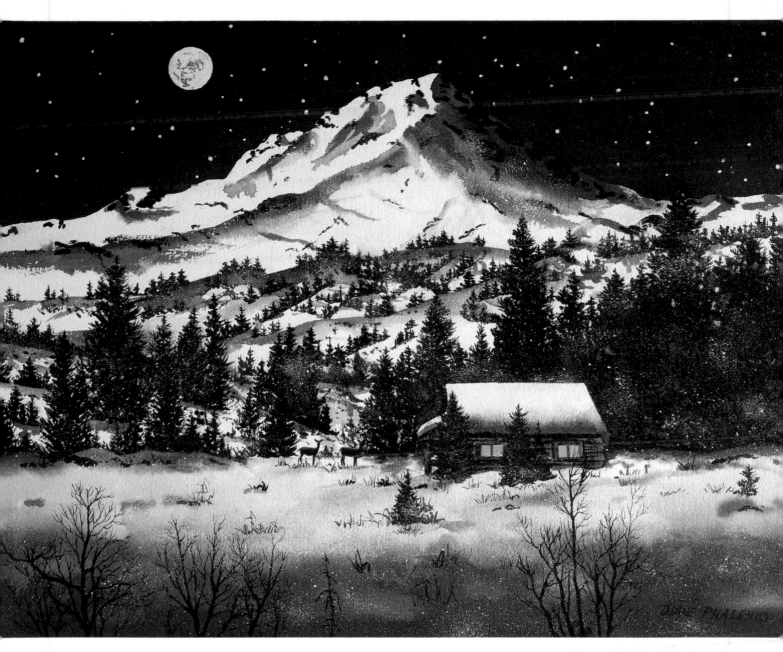

Step Seven

Finish the details of the deer and cabin with a Burnt Sienna wash and Sepia shadows. Use New Gamboge in well-lit windows. Add further detail with Sepia for foreground trees and grasses. Finish the overall painting with a sprinkle of Permanent White gouache applied with a toothbrush in a spatter technique.

SPATTERING

Create fine speckles and random spatters of paint by pulling your thumb or a palette knife toward you over the paint-loaded bristles of an old toothbrush.

Adirondack Chairs and Irises

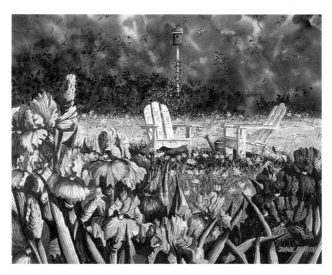

I like the look of Adirondack chairs and wanted to paint them in a spring setting. In this project you can feel the start of spring in the beautiful irises, and the chairs seem to invite you to rest awhile and enjoy the sunny day.

MATERIALS

- Tracing paper, pencil, eraser
- 15″×20″ Arches 300 lb. cold-pressed watercolor paper
- Artist's tape
- Masking fluid
- Rubber cement pick-up
- Tissues

BRUSHES
- no. 1 round
- no. 2 round
- no. 3 round
- no. 6 round
- no. 10 round
- ¾-inch flat
- 1½-inch flat

PALETTE

Aureolin Yellow	Cadmium Yellow	New Gamboge	Yellow Ochre	Burnt Sienna	Sepia	Cadmium Orange
Cadmium Red	Antwerp Blue	Cerulean Blue	Cobalt Blue	Winsor Blue	Carbazole Violet	Cobalt Violet
Permanent Green	Sap Green	Winsor Green	Naphthamide Maroon or Alizarin Crimson	Opera or Permanent Rose	Permanent White gouache	Fluorescent Yellow gouache

Step One

I made several sketches of the arrangement of the Adirondack chairs and iris garden before arriving at the final composition. Trace in detail the setting of the chairs, flowers and birdhouse on watercolor paper.

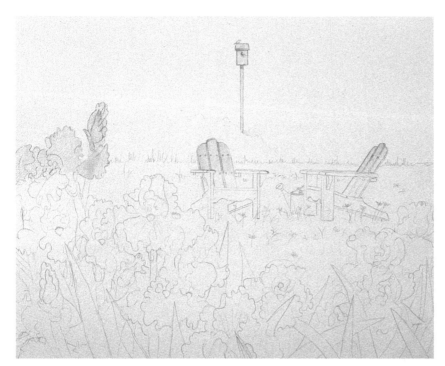

Step Two

After transferring the sketch onto the paper, apply masking fluid to areas that need to be protected from the initial color wash. Carefully mask the tops of the irises, the birdhouse and pole, the bluebird and the tops of the Adirondack chairs using a no. 6 round brush. Mask the grasses in the background with a no. 1 round detail brush.

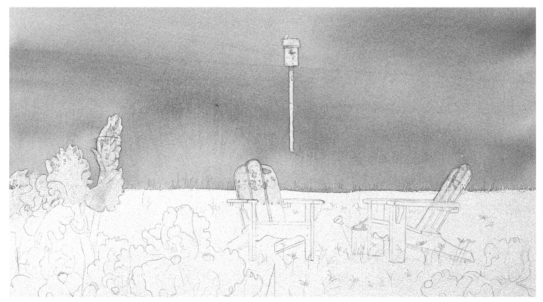

Step Three

Use a 1½-inch flat wash brush to wet the paper with clear water in the background area. While wet, lay in your initial wash of New Gamboge and Permanent Green, working from top to bottom. Always keep a tissue handy to mop up any water that may trickle down past the background.

Step Four

As the paper begins to dry and loses a bit of its shine, add in a second wash for the dark foliage with a large round brush loaded with Permanent Green, Sap Green and Winsor Blue. Let those colors mingle and flow. Continue with an additional darker wash toward the bottom, just above the grasses, of Winsor Blue and a very small amount of Alizarin Crimson. Dab the wash with a crumpled tissue to suggest even more texture in the foliage.

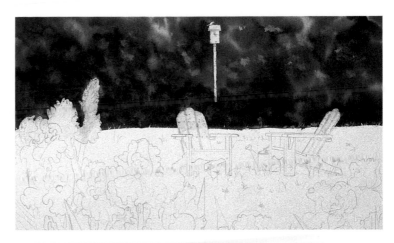

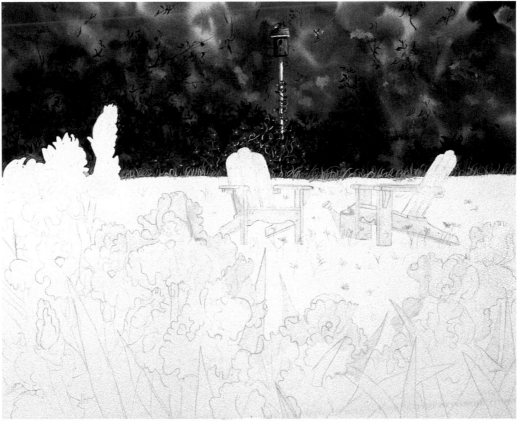

Step Five

When the background is dry, remove the masking fluid. I wanted to keep the background simple and dark to offset the bright colors of the irises and the white of the Adirondack chairs. Add further detail very loosely to suggest leaf patterns using a no. 10 round brush and a mixture of Permanent Green and Winsor Blue. Add some branch details with Sepia.

Paint the birdhouse with a mixture of Yellow Ochre and Sepia for the shadows and wood definition. Paint in the bluebird with Cobalt Blue on the wing area and Burnt Sienna on the breast area. For further definition of the birdhouse, add a trellis of flowers using a no. 1 round detail brush and a mixture of Cobalt Blue and Carbazole Violet.

Add New Gamboge to the centers of the small purple flowers. Remove the mask that protected the light grass area and paint it with Permanent Green and Cadmium Yellow. Apply masking fluid to the Adirondack chairs to retain their whiteness. The daisies in the middle area and tops of the irises also need to be protected. This allows more freedom in applying the middle ground washes.

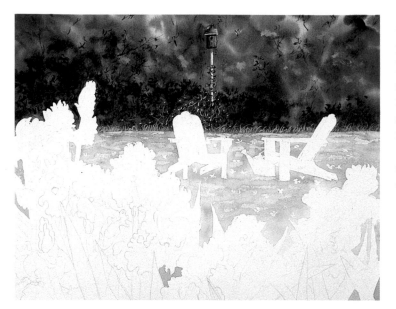

Step Six

Lay in a wash of Aureolin Yellow, Cobalt Blue and Sap Green in the middle area with a ¾-inch flat wash brush. Work around the masked areas. While this wash is wet, suggest small areas of shadow and grasses with Permanent Green.

Make sure the paper is completely dry, and then remove all the masking fluid from the chairs and the tops of the irises.

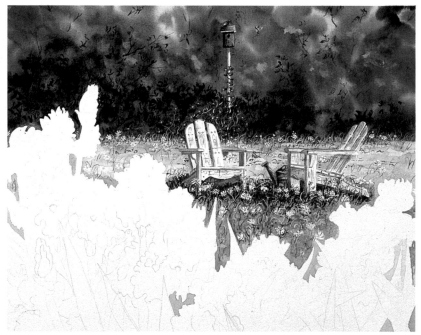

Step Seven

Add grass details randomly throughout the middle area with a no. 1 round brush and a mixture of Winsor Blue and Permanent Green. Lay in the shadow of the Adirondack chairs with a no. 3 round brush and Antwerp Blue. Use Cerulean Blue and a small no. 1 detail brush to suggest wood grain on the chairs. The chairs are kept light even in the shadow areas to suggest the brightness of the sun. Add darker grass shadows under the chairs with Winsor Blue and Permanent Green.

Continue to add detail to the middle area. Further define the watering can with a light wash of Cerulean Blue and Sepia. Using a mixture of Cadmium Yellow and Permanent White, add more detail to the daisies. Here you may also add more daisies with Permanent White and a no. 1 round. Add Permanent Green to the chair shadows and down to the tops of the irises. This anchors the chairs and irises to keep them from looking cut-out. More definition may be added to the grass at this point with Permanent Green and Winsor Blue to enhance the shadows and texture. You may also enhance the chair shadows with Cobalt Blue.

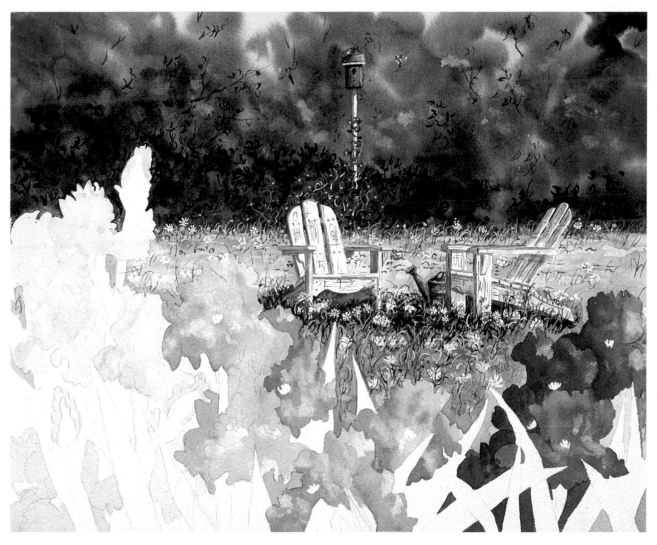

Step Eight

With a wet no. 6 brush, lay in a loose wash of Cobalt Blue and Opera for the light purple irises, being careful that the color doesn't bleed into the green of the grass area. While the paper is still wet, use a crumpled tissue to dab areas of the petal that are facing the sun for more of a sunlit effect. The tissue will absorb some of the color and lighten that area of the petal.

Add Naphthamide Maroon to the wash used on the purple irises. Use a wet no. 6 round brush to lay a wash of this color over the maroon irises. Employ the same crumpled tissue technique for the lacy edges.

Lay in Cadmium Yellow washes for the yellow irises. Use the crumpled tissue on the light areas facing the sun.

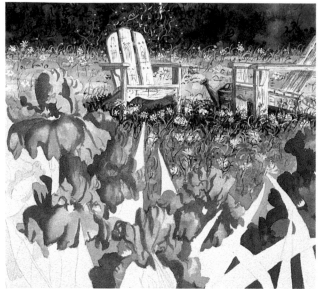

Step Nine

Use a no. 6 brush to lay in darker shadows on the purple irises with a mixture of Cobalt Violet Deep and Cobalt Blue. Use another no. 6 brush wet with clear water to blend between the shadows and light areas of each iris.

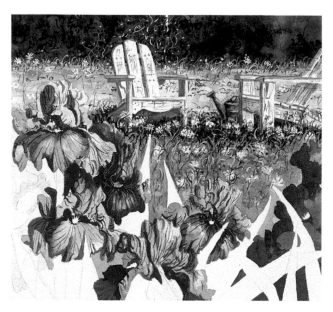

Step Ten

After the shadows are dry, paint the detail of veins and petals using a no. 2 round brush with more paint and less water on the brush. Use Carbazole Violet to detail areas of the petals that fall in dark shadows.

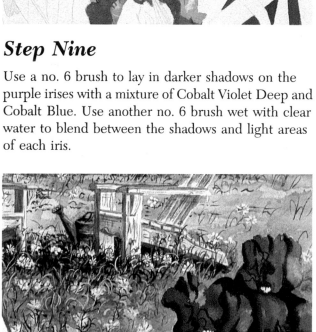

Step Eleven

Block in washes for the shadows in the maroon irises using a mix of Cobalt Blue and Naphthamide Maroon. Use the same technique as you did for the purple irises.

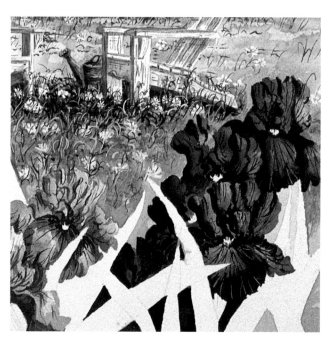

Step Twelve

Add detail to the maroon petals with the small no. 1 round brush. Suggest veins using Cobalt Blue and Naphthamide Maroon.

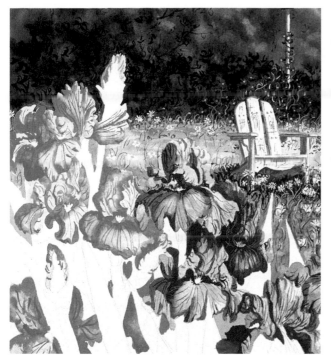

Step Thirteen

For the shadows in the golden irises, use a blend of Cadmium Yellow and Cadmium Red. These two colors mix well together and will produce a nice orange for lighter shadow areas.

Step Fourteen

When the shadows are dry, define the petals in the sunlit areas with a no. 1 detail brush and a mix of Cadmium Yellow and Cadmium Orange. For additional shadow definition, use a wet wash of Naphthamide Maroon in darker shadows, crevices and for veins on the petals.

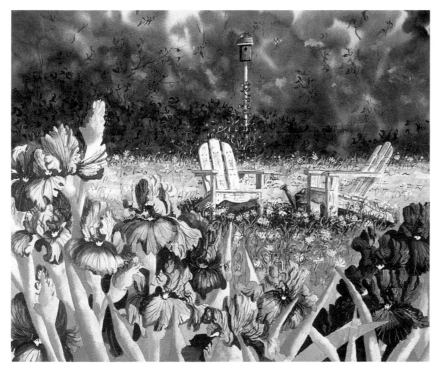

Step Fifteen

Use a mix of Cobalt Blue and Cadmium Yellow for the leaves and stems of the irises. First run a no. 6 round brush loaded with this color along the shadow part of the stem. Then take a brush loaded with clean water and go along your first strokes so they blend toward the sunlit area of the stem. This will separate the Cadmium Yellow from the mix. I call this "floating" a color. Reserve the Cobalt Blue and Cadmium Yellow mixture on your palette as it will be used again to define veins in step sixteen.

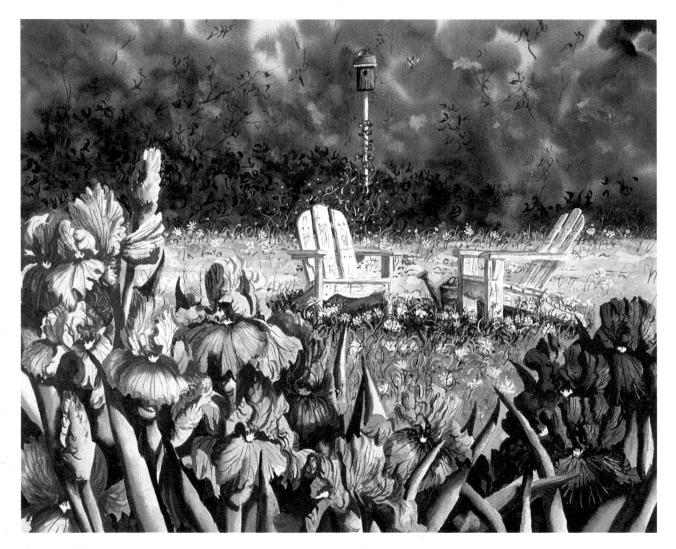

Step Sixteen

Use a mix of Winsor Green and Antwerp Blue on a no. 6 round to run a dark shadow along the shaded edge of the stem. Run water along this stroke to create a soft shadow, again using a no. 6 round.

Add more detailed veins with a no. 2 round brush of Cobalt Blue and Cadmium Yellow. To detail the veins that fall in the darkest shadows, use Winsor Green and Antwerp Blue. This dark blend may also be used to work around the chairs and foreground grasses to tie everything together.

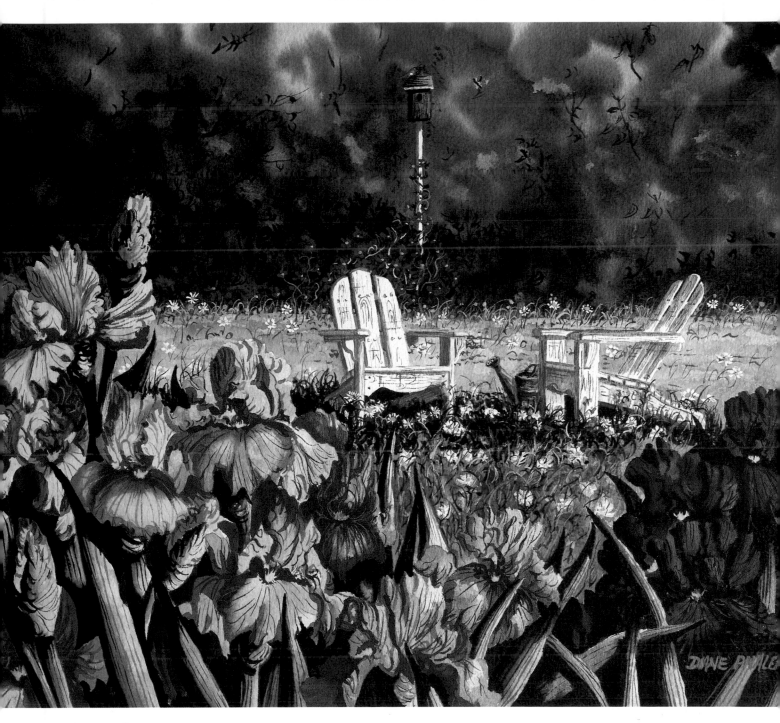

Step Seventeen

Finish the irises by adding Aureolin Yellow to define the centers. You may wish to add a bright wash of Cadmium Yellow and Cobalt Blue to the middle ground or even a quick, wet wash of Fluorescent Yellow. Also add a quick wash of Winsor Green to the shadow under the chairs and to the tops of the irises.

Simple Farm House and Crocuses

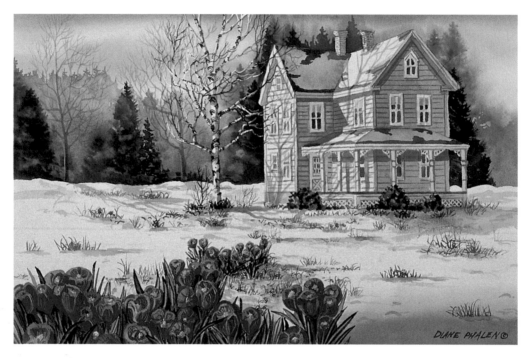

I discovered this charming white farmhouse on one of my back-road jaunts. I enjoy the look of it so much that I've portrayed it in many settings and seasons.

MATERIALS

- Tracing paper, pencil, eraser
- 15″×20″ Arches 300 lb. cold-pressed watercolor paper
- Artist's tape
- Masking fluid
- Rubber cement pick-up
- Tissues

BRUSHES
- no. 0 round
- no. 2 round
- no. 6 round
- 1½-inch flat

PALETTE

Naples Yellow

New Gamboge

Burnt Sienna

Permanent Rose

Cobalt Blue

Ultramarine Blue

Sap Green

Payne's Gray

Step One

Transfer the drawing to your watercolor paper.

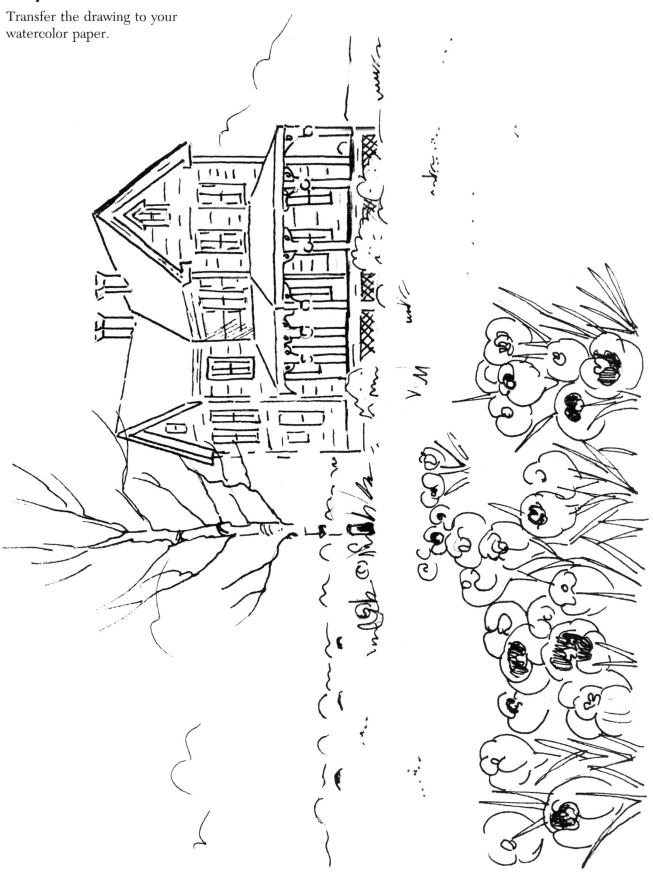

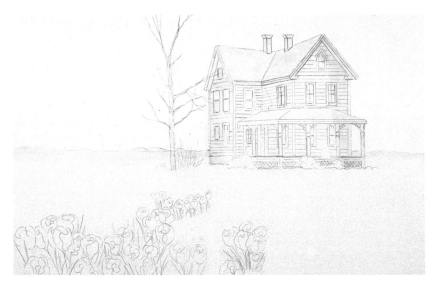

Step Two

Mask the roof, the sides of the house, the birch tree and the background snow that meets the sky area to protect them from the sky and background washes.

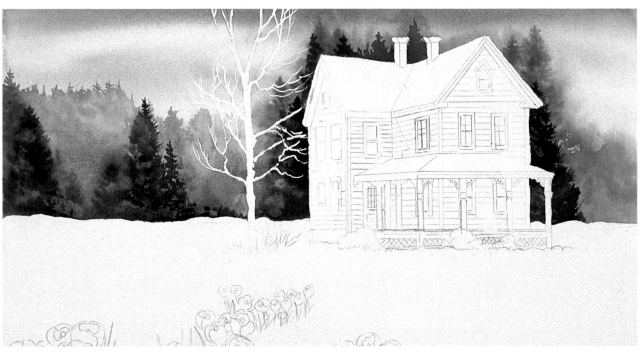

Step Three

I threw everything into this background wash, but your colors can vary. Using a 1½-inch wash brush, put down clean water over the entire sky area. Lay in Naples Yellow over the wet area and add some Cobalt Blue toward the horizon and middle area. While the sky is very wet, start the background trees and evergreens. Suggest mountains with Cobalt Blue and Payne's Gray. Add random washes of Permanent Rose, Burnt Sienna, Sap Green and New Gamboge. As the paper begins to dry and loses its shine, add a mixture of Ultramarine Blue and Sap Green for the foreground evergreens.

When the entire background is dry, completely remove the masking fluid.

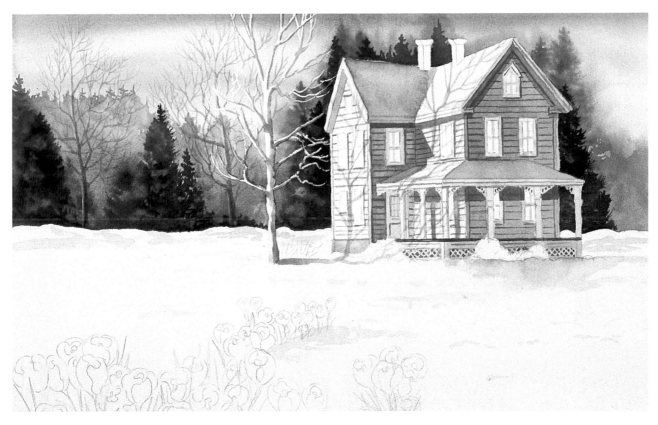

Step Four

Add the background trees with a mix of Payne's Gray and Cobalt Blue. Also use this color under the porch. Using Cobalt Blue, add shadows to the birch tree and house. Use loose wet washes of Cobalt Blue for the overall shadows. For more detailed shadows use less water on your brush. Dry-brush Cobalt Blue for siding lines, window definition and shadows against the house. Use a light wash of Cobalt Blue to suggest shadows in the snow around the house.

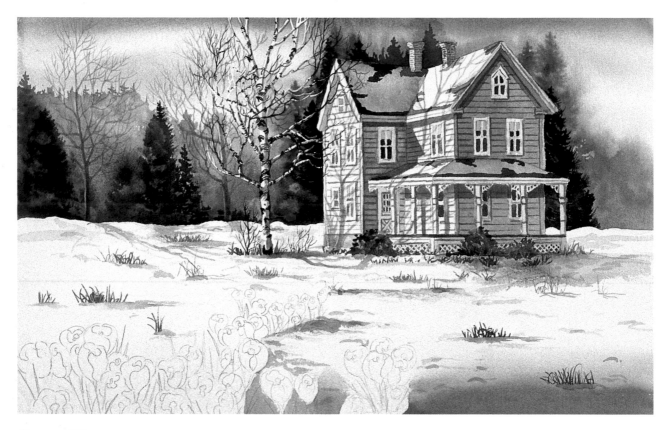

Step Five

Detail the bark of the birch tree using Payne's Gray and Burnt Sienna. Add Burnt Sienna branches. Paint the roof with Payne's Gray. Where the snow has melted, use a heavier dry brush. Further define the windows with Payne's Gray. Use Naples Yellow for lighter areas of shadow and a mix of Naples Yellow and Burnt Sienna for shadows around the house.

Paint the chimney with Burnt Sienna. Wash Payne's Gray over the shadow areas. Further define the shadows using a mix of Cobalt Blue and Permanent Rose for the lower snow shadows and shadows closer to the house.

Add shrubs and grasses around the house with a mix of Sap Green and New Gamboge.

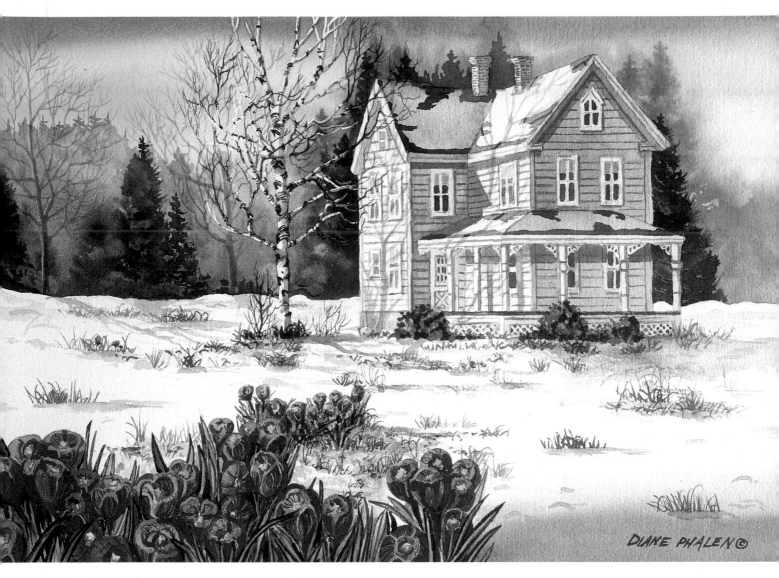

Step Six

Starting with the light areas of the crocuses, apply a mix of Cobalt Blue and Permanent Rose—using more Cobalt than Rose—in wet, loose washes. Wash on just enough color to give the paper a purple hue. When the initial layer of color dries, add darker purple shadows using a dry brush and a more concentrated wash of Cobalt Blue and Permanent Rose.

For darker shadows, use Ultramarine Blue and Permanent Rose. For the lighter stem areas around the crocuses use Sap Green and New Gamboge; use straight Sap Green for darker areas, especially on each side of the stem. For the flower centers use New Gamboge, adding Burnt Sienna in the shadows. Finally, add some dirt showing through the snow using Naples Yellow and Burnt Sienna, and add some grass details with Sap Green.

Sunset Visitors

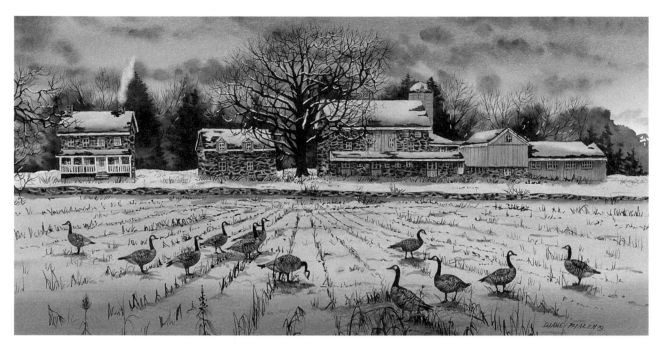

I fell in love with this stone house and its farm buildings located in New Hope, Pennsylvania. Every year when I visit, my sister Mary and I spend a few days scouting the back roads of New Hope and surrounding areas, so that I won't miss a beautiful barn or quaint cottage. The Canada geese are frequent visitors throughout the fall and winter months.

MATERIALS

- Tracing paper, pencil, eraser
- 15″ × 20″ Arches 300 lb. cold-pressed watercolor paper
- Artist's tape
- Masking fluid
- Rubber cement pick-up
- Tissues

BRUSHES
- no. 1 round
- no. 6 round
- 1½-inch flat
- bristle brush

PALETTE

Naples Yellow	Burnt Sienna	Sepia	Permanent Rose	Cerulean Blue
Cobalt Blue	Winsor Blue	Ultramarine Turquoise	Permanent White gouache	Fluorescent Magenta gouache (optional)

Step One

Transfer the drawing to your
watercolor paper.

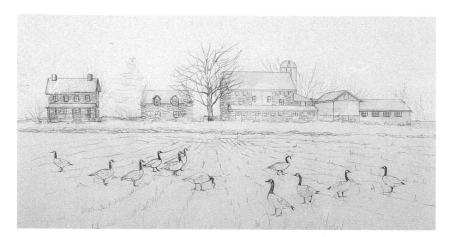

Step Two

Mask the tops and sides of the roofs and along the horizon line.

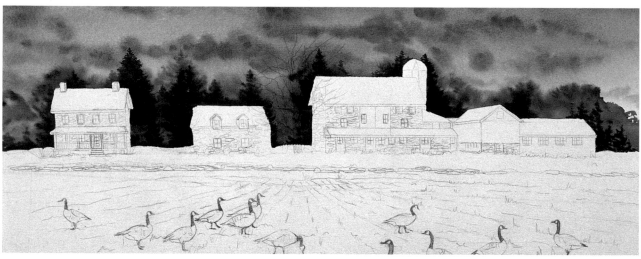

Step Three

Wet the sky area with a 1½-inch wash brush, making sure the sky area is very wet before beginning the initial wash. Start with a mix of Naples Yellow and Permanent Rose over the entire sky for background color. If desired, add Fluorescent Magenta to the mix for an extra glow. While the sky is still extremely wet, add random clouds with a no. 6 round wash. Dab Cobalt Blue and Permanent Rose in different areas and let them mingle with the initial sky wash.

While the sky is drying, add Cobalt Blue to the clouds. Add the background tree line with a mixture of Sepia and Burnt Sienna. While this area is beginning to lose its shine, add a suggestion of fir trees with Ultramarine Turquoise. When dry, completely remove the mask.

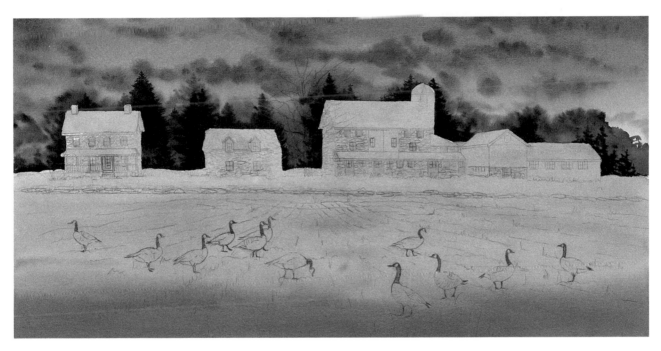

Step Four

Using a wet, diluted wash of Cobalt Blue and Permanent Rose, lay in color over the farm in the background and to the bottom of the foreground fields. Use a more concentrated mixture of Cobalt Blue and Permanent Rose over the entire bottom of the painting—this area of the painting now appears to be in shadow. When the paper is completely dry, apply masking fluid to the stonework of the farmhouse, barn and buildings. This will later be used to suggest mortar between the stones. You can also paint the stones individually—this technique is taught in project eleven.

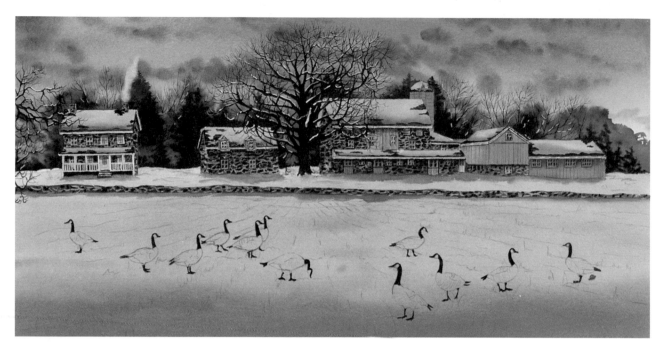

Step Five

Once the masking fluid is dry, use a no. 6 brush to wash Sepia over the stonework areas of the farmhouse, barn and other buildings.

Use a more heavily concentrated mixture of Cobalt Blue and Permanent Rose to add blending shadows to the roofs of buildings, as well as around the bottoms of buildings and under the stonework. Using heavier Sepia on a dry brush, add the trees by the barn and behind the buildings. Remove the mask from the stonework and go over it with a very diluted wash of Sepia to blend further. Define the stonework with dry-brush mixtures of Sepia and Winsor Blue, and some Burnt Sienna.

Randomly use the same mix of Sepia and Winsor Blue for stones in the shadows, roof lines where snow has melted, shadows in the roof overhang and windows, and the necks, feet and tail feathers of the Canada geese. Add Permanent White gouache to the branches of the trees, both foreground and background. Create some smoke coming out of the chimney by scrubbing the paper with a bristle brush and dabbing off paint with a tissue.

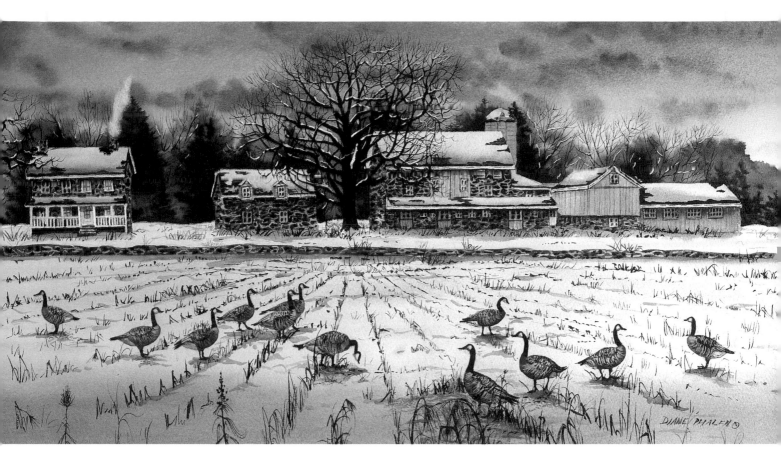

Step Six

Suggest weeds by the farmhouse and barn using Sepia and Burnt Sienna. Use the same technique for the cornstalks and weeds around the geese, but use mixtures of Sepia and Winsor Blue.

Using a no. 6 round loaded with Sepia and Cerulean Blue, do a blending wash on the bodies of the geese, blending from belly to top feathers. Leave the area by the tail white. Use a blending wash of Cobalt Blue on this area, and also on the chin straps on the neck. When the intial wash is completely dry, detail the feathers with a no. 1 round brush. Leave areas between the feathers unpainted to show separation. If you wish, you can use masking fluid to create separations, as you did for the stonework in step four.

For a final touch add darker shadows of Cobalt Blue and Permanent Rose beneath the geese and throughout the broken cornstalks.

Schoolhouse in Spring

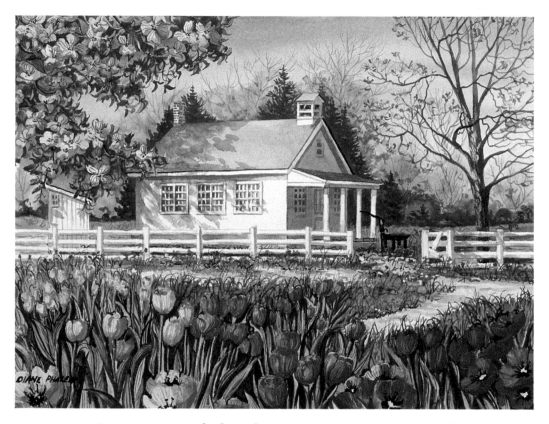

In my many travels throughout Lancaster, Pennsylvania, and surrounding areas, I came across this Amish schoolhouse. Sometimes you can see the children at play, but there are also times when it is a quiet haven where you can enjoy the beauty of the seasons.

MATERIALS

- Tracing paper, pencil, eraser
- 15″ × 22″ Arches 300 lb. cold-pressed watercolor paper
- Artist's tape
- Masking fluid
- Rubber cement pick-up
- Tissues

BRUSHES
- no. 0 round
- no. 2 round
- no. 6 round
- 1½-inch flat

PALETTE

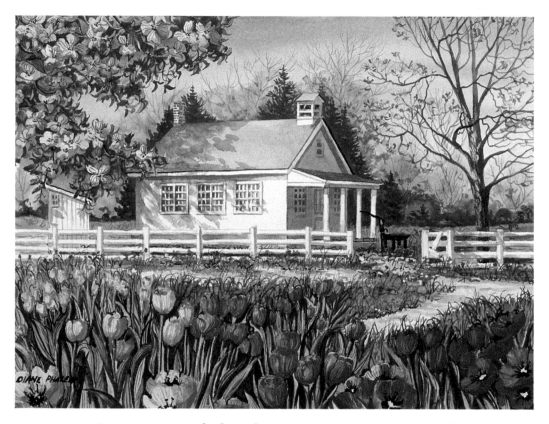					
New Gamboge	Winsor Yellow	Burnt Sienna	Alizarin Crimson	Cadmium Red	Permanent Rose
Cobalt Blue	Winsor Blue	Sap Green	Winsor Green	Payne's Gray	

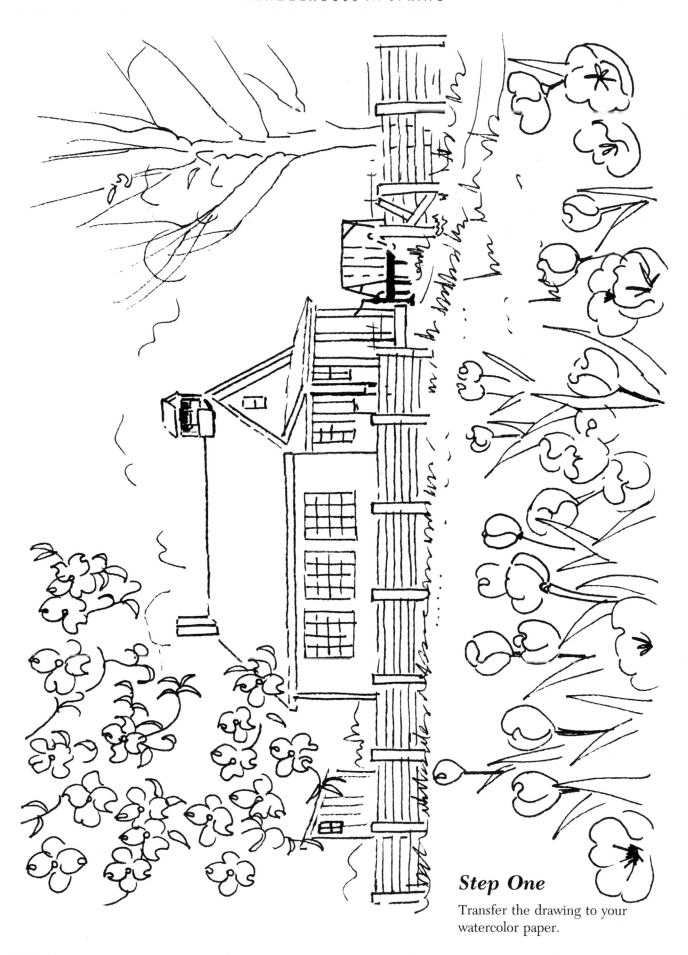

Step One

Transfer the drawing to your
watercolor paper.

Step Two

Mask off the blossoms of the dogwood tree, the branches and some leaves. Also mask the outhouse and the schoolhouse roof and sides.

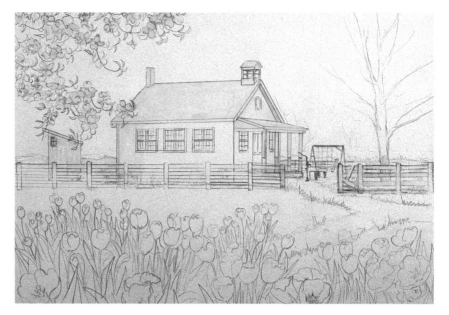

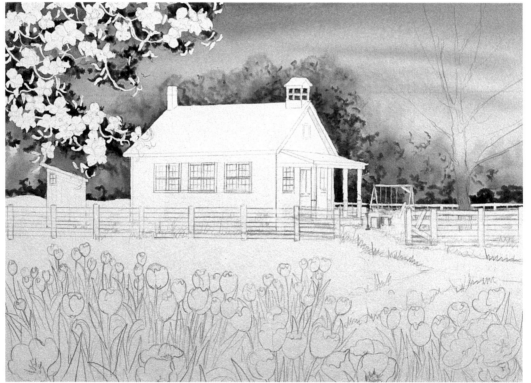

Step Three

Lay in a very wet wash of Cobalt Blue for the sky area. While this is wet, start laying in background foliage with Sap Green. As the paper is beginning to dry and lose its shine, add suggestions of dogwood blossoms with Permanent Rose (Quin Pink can also be used). Add darker suggestions of foliage with Winsor Green and a no. 6 round. Let this area dry completely, then remove the masking fluid.

Step Four

Lay in a wet wash of Cobalt Blue and Payne's Gray using a no. 6 round for the roof of the schoolhouse and the tree on the left. Define the branches of the tree with a no. 0 brush. Add new spring leaves with Sap Green, New Gamboge and Winsor Green. Using the same greens, carry color down the fence line between the rails in light washes. Add leaves to the dogwood branches with New Gamboge and Winsor Green. Add background leaves and leaves in shadow with Winsor Green and a no. 0 brush. Using Burnt Sienna, suggest detail on the dogwood branches.

At this time I decided to delete the swing set behind the school. This is replaced by a wash of Winsor Green. Mask the windows of the schoolhouse with a no. 0 brush. Also mask the fence rail in front of the schoolhouse. Evergreens are added to the background with a no. 2 detail dry-brush of Winsor Green.

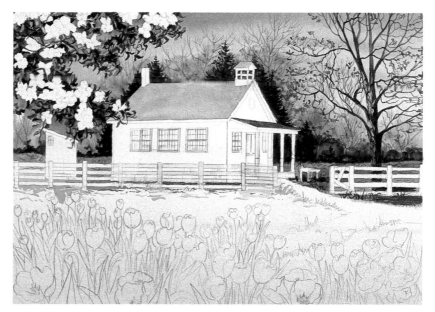

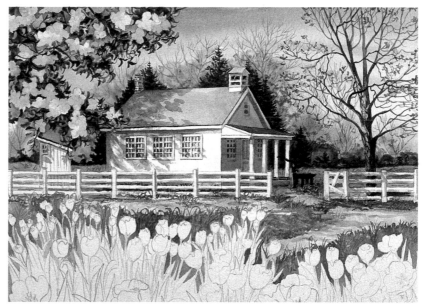

Step Five

Using loose, wet washes of Cobalt Blue, lay in dappled shadows and the darker shadows of the schoolhouse using a mix of Cobalt Blue and Payne's Gray. Add dappled shadows to the roof, and reflections in the windows. Lay in very wet, loose washes of Permanent Rose for the dogwood blossoms. Lay in very wet washes of Winsor Green and New Gamboge in grassy areas around the foreground tulips and schoolhouse. Remove the masking fluid on the fence and windows, using Cobalt Blue to blend with existing shadows. Detail the water pump with Payne's Gray.

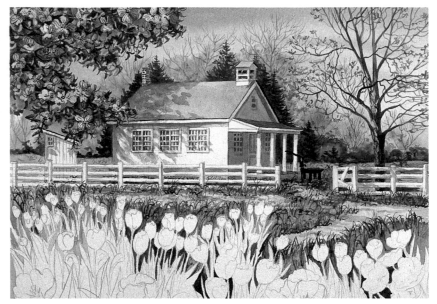

Step Six

Finish the background detail starting with the dogwood blossoms. Create shadow areas on the petals with Permanent Rose. Wash over areas deeper in shadow with Cobalt Blue. Use a dry no. 0 detail brush and Permanent Rose to further define the blossom veins. Use New Gamboge for the petal centers. When the centers dry more, define them with Winsor Green. Use Winsor Green to further define the leaves in shadow and around the dogwood blossoms.

Using Winsor Green and a no. 0 brush, define the grass throughout the painting, especially along the fence area. Add New Gamboge for sunlit blades. Carry Winsor Green down into the tulip area, working around the tulips and stems with a no. 2 round brush.

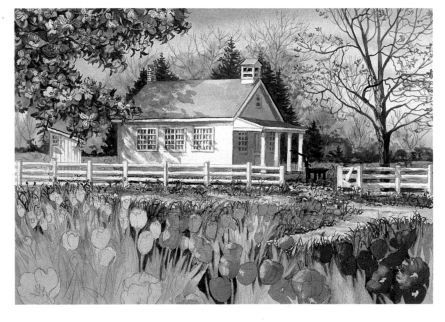

Step Seven

Start by laying in washes of Permanent Rose for the pink tulips, using the same color combinations as in the dogwoods. For purple tulips use a mix of Permanent Rose and Cobalt Blue. For yellow tulips use Winsor Yellow and for red tulips use Cadmium Red. Also lay in a general wash of Winsor Yellow and Winsor Green—these are good, bright green spring colors—for the tulip leaves and stems.

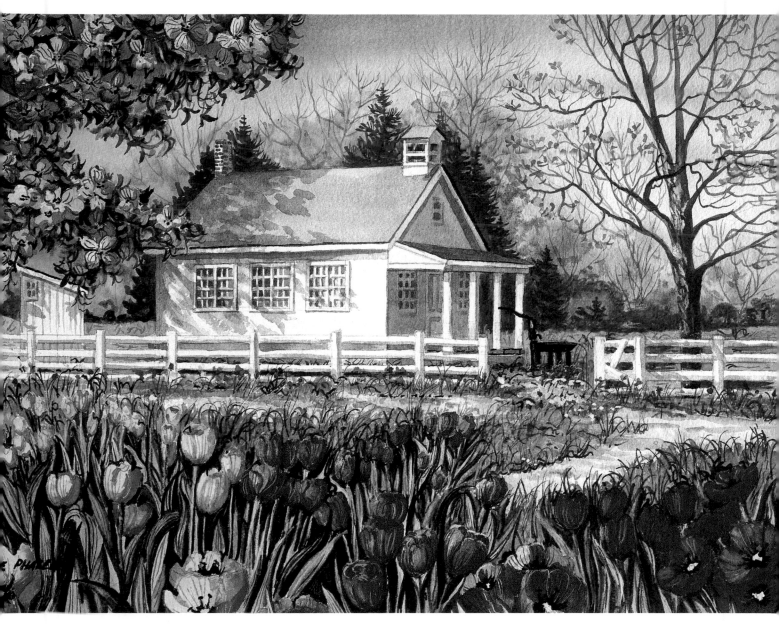

Step Eight

Using both blending and dry-brush techniques, go along the shadow areas of the leaves, stem and veins with a mix of Winsor Green and Winsor Blue on a no. 6 round brush. Stroke back along these areas with a no. 6 round and clear water (less water for crevice areas). Cobalt Blue may be added for darker crevice shadows. For purple tulip shadows add a heavier concentrate of Permanent Rose and Cobalt Blue. For yellow tulip shadows use New Gamboge and Cadmium Red. For red tulip shadows use Alizarin Crimson.

Covered Bridge

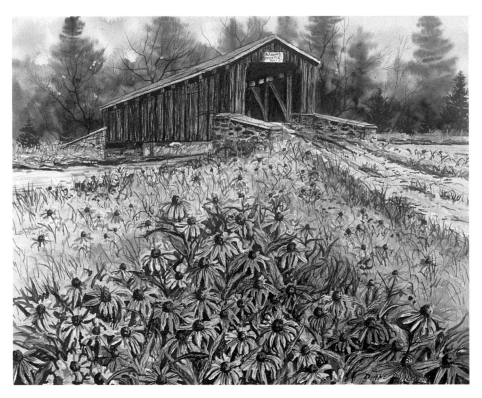

Pennsylvania is known for its many covered bridges—a favorite subject of mine to paint. I love to stand inside the bridge opening and smell the old wood, listening to the rushing water below. This particular bridge was fun to paint because of its original old wood.

M A T E R I A L S

- Tracing paper, pencil, eraser
- 15″×20″ 300 lb. Arches cold-pressed watercolor paper
- Artist's tape
- Masking fluid
- Rubber cement pick-up
- Tissues
- Palette knife

BRUSHES
- no. 0 round
- no. 6 round
- 1-inch flat

PALETTE

Cadmium Yellow	New Gamboge	Winsor Yellow	Yellow Ochre	Burnt Sienna	Burnt Umber
Sepia	Alizarin Crimson	Permanent Rose	Ultramarine Blue	Permanent Green	

Step One

Transfer the drawing to your
watercolor paper.

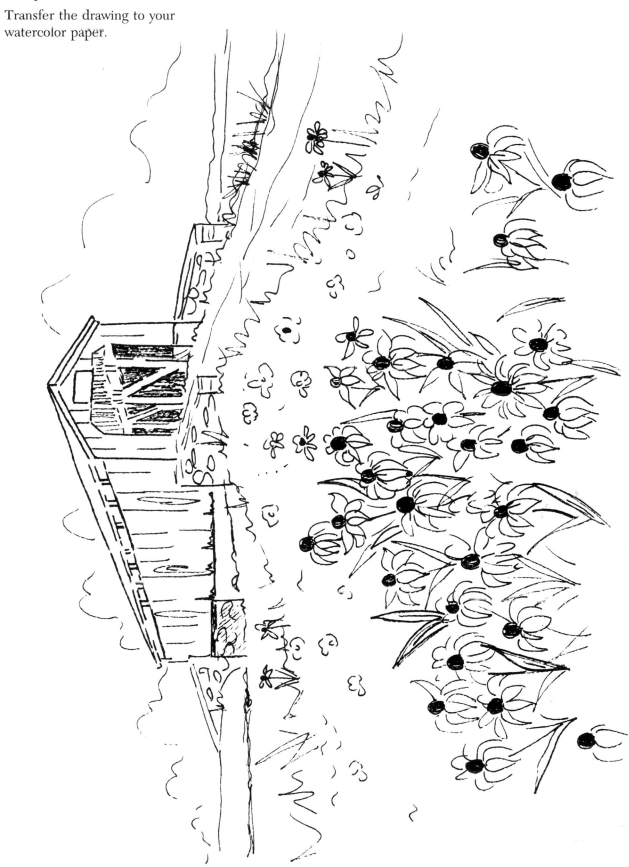

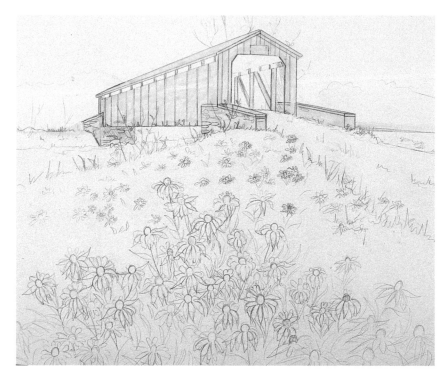

Step Two

Apply masking fluid to the entire covered bridge, except the opening, to protect it from sky washes. Let this dry completely before beginning step three.

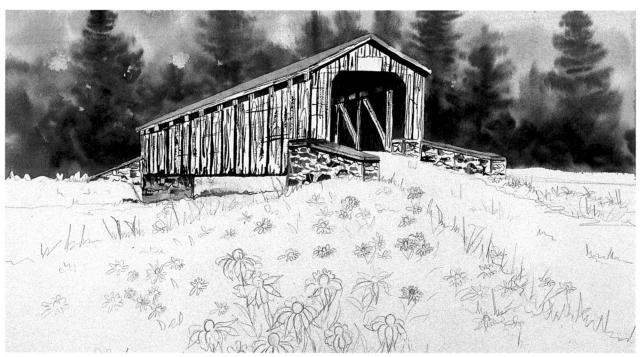

Step Three

Use a 1-inch wash brush full of clear water to wet the entire sky area behind the covered bridge. While this is very wet, lay in a Permanent Green and Winsor Yellow mixture to suggest background foliage. As this dries, lay in darker foliage with Ultramarine Blue and Permanent Green.

Use Sepia to paint shadows in the covered bridge opening and under the eaves. When all areas are completely dry, remove the masking fluid. Use less-diluted Sepia on a no. 0 detail brush to add wood texture to the covered bridge's outside and opening.

Paint the stones individually with a more watery wash of Sepia. Using a no. 6 round brush and a mixture of Sepia and Ultramarine Blue, complete the roof.

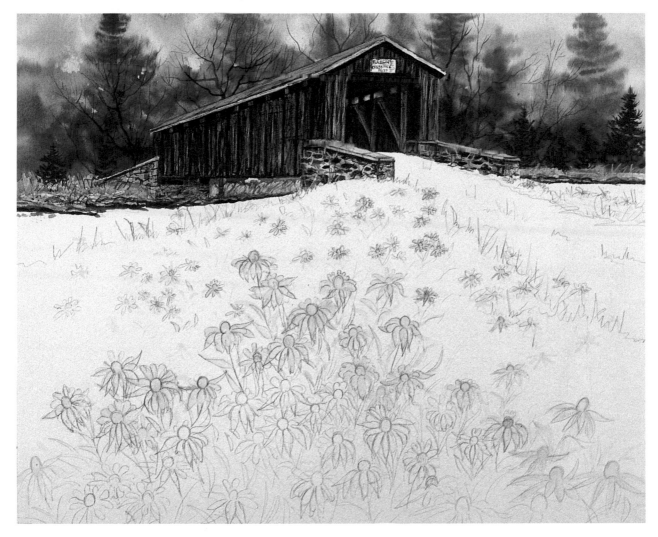

Step Four

When the wood texture is completely dry, use a 1-inch flat brush to wash Burnt Sienna quickly over all the wood of the covered bridge, trying not to disturb the Sepia wood grain underneath. Wash over the stonework using Sepia and Ultramarine Blue. Add shadows on the left side of the covered bridge. Use a no. 0 brush to add background branches among the foliage.

Mask out the wildflowers and some selected foreground flowers. Allow this to dry completely before beginning step five.

Add Permanent Green and Burnt Sienna to the background grasses near the water. Scrape over this area with a palette knife for texture.

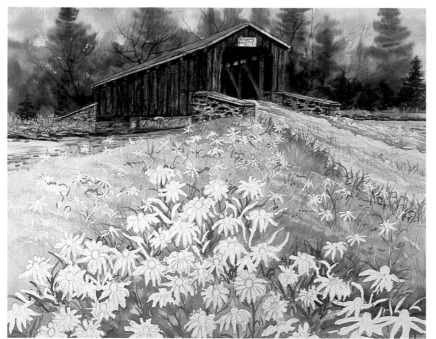

Step Five

Begin the dirt pathway with a wash of Yellow Ochre. Randomly add Burnt Sienna and Sepia to the path. While this is wet, scrape in highlights with the heel of the palette knife. Let this area dry completely before beginning the grassy areas.

Starting in the sunlit area of the grass, use Cadmium Yellow and a small amount of Permanent Green. Add more Permanent Green as you work toward the bottom of the painting.

Use a palette knife to suggest additional shadows by scraping with the heel of your knife. Suggest grass using the tip of your palette knife blade. Dab with a crumpled tissue for additional grass texture.

Step Six

Begin filling in the cone flowers with wet washes of Permanent Rose. Use New Gamboge for the petals of the brown-eyed Susans and Burnt Sienna for their centers. Use Permanent Green to redefine some of the foreground grasses and stems before adding the final shadows.

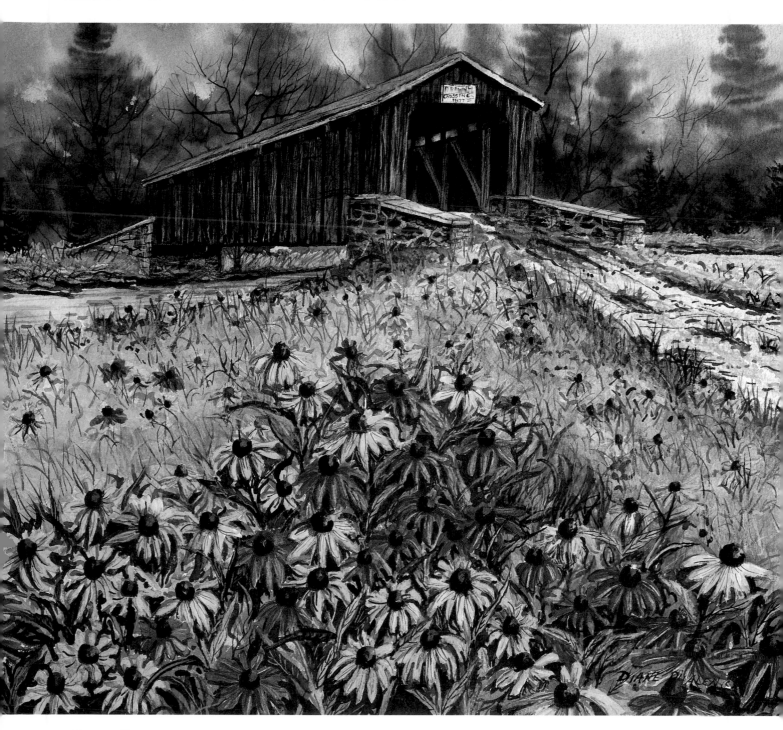

Step Seven

Finish the pink cone flowers by shading and veining the petals with Alizarin Crimson. Use a mixture of Permanent Rose and New Gamboge to shade and paint detail lines in the brown-eyed Susans' petals. Use Burnt Umber for shadows and texture in the flower centers, and to further suggest texture in the pathway.

Use a no. 6 round loaded with Ultramarine Blue and Permanent Green for darker shadows in the foreground flower leaves and stems and for detail in the grass. If desired, use a wet, loose wash of New Gamboge over the grasses for a more sunlit effect.

Pigeon Point Lighthouse and Hollyhocks

I lived near the Santa Cruz Pacific Coast of California for many years. My favorite lighthouse to visit and paint was Pigeon Point Lighthouse in Half Moon Bay. Although this painting shows a summery array of hollyhocks, in the fall the field in front of the lighthouse bursts with pumpkins on the vine.

MATERIALS

- Tracing paper, pencil, eraser
- 18″ × 22″ Arches 300 lb. cold-pressed watercolor paper
- Artist's tape
- Masking fluid
- Rubber cement pick-up
- Tissues
- Palette knife
- Nail file
- White watercolor pencil
- Straw Yellow watercolor pencil (optional)

BRUSHES
- no. 2 round
- no. 6 round
- 1-inch flat
- 1½-inch flat

PALETTE

Yellow Ochre	Spectrum Yellow	Winsor Yellow	Burnt Sienna	Sepia	Cadmium Orange

Permanent Red Deep	Cobalt Blue	Ultramarine Blue	Permanent Green	Sap Green	Payne's Gray

Alizarin Crimson	Permanent Rose	Fluorescent Magenta gouache (optional)	Fluorescent Yellow gouache (optional)	Fluorescent Red gouache (optional)

Step One

Transfer the drawing to your watercolor paper.

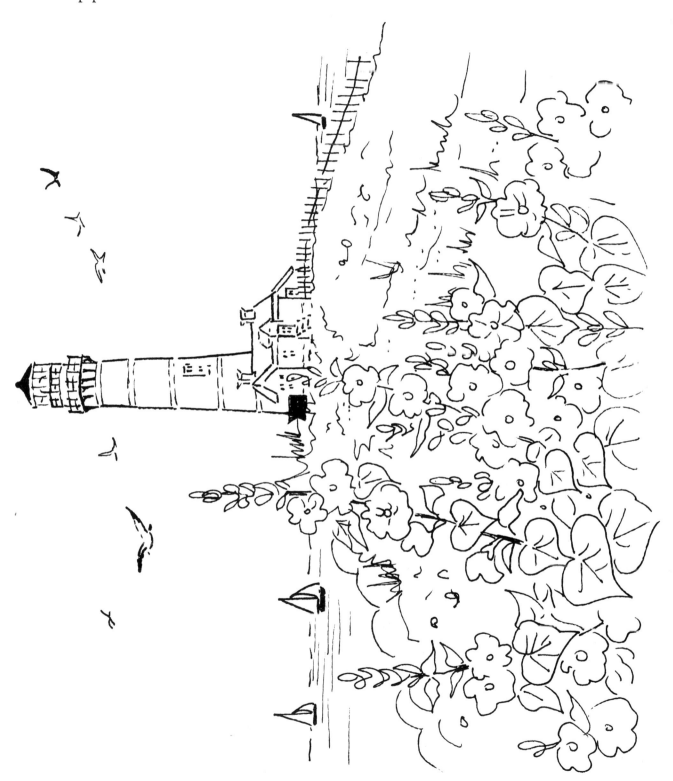

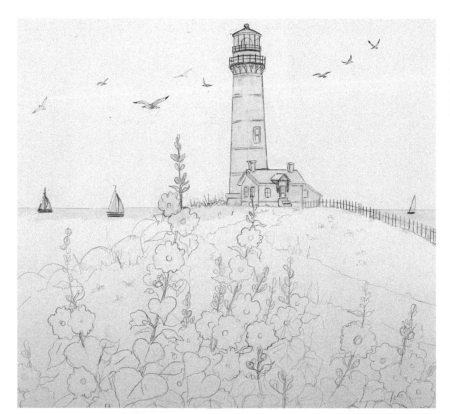

Step Two

Apply masking fluid to all areas that meet the sky: seagulls, ocean, lighthouse, sailboats and tops of hollyhocks. Allow to dry completely before beginning step three.

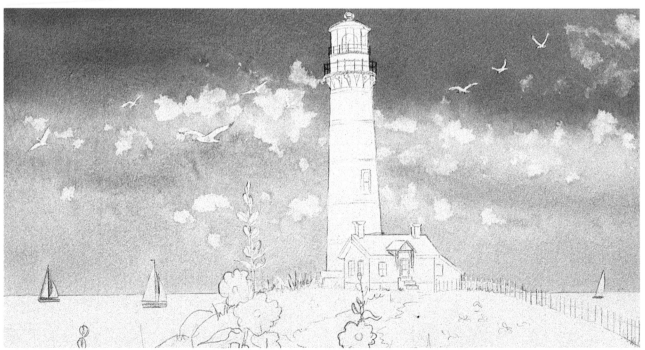

Step Three

Lay in an initial wash of clear water for the sky using a 1½-inch wash brush, completely wetting the sky area. Use Cobalt Blue across the top of the painting and blend toward the bottom of the sky. While the paper is still wet, use a crumpled tissue to blot out the suggestion of clouds in the sky area. Allow the paper to dry completely, then remove all masking fluid.

Step Four

Once again, mask areas that need to be protected from color, such as the fence, light, lighthouse rings, sailboats, rocks and areas in the grass that will suggest flowers. When the mask is completely dry, use a wet no. 6 round brush loaded with Ultramarine Blue for shadows, then blend by stroking toward the sunlight on both the lighthouse and house with a brush of clear water. For darker shadows, use a mixture of Ultramarine Blue and Permanent Rose. Use the same colors for the shadows of the seagulls and for the ocean.

Use wet blending strokes for the ocean. While this wash is drying, scrape in lines with the tip of your palette knife, nail file or white watercolor pencil. Allow this area to dry completely before removing masking fluid in all areas except the middle grasses.

Use Payne's Gray for the roofs of both the house and the lighthouse, using a more concentrated wash for areas that fall into shadow. Also use Payne's Gray for the lighthouse light, seagulls' wing tips and window panes. Use Burnt Sienna to paint the house's chimneys and Cadmium Orange for the beaks and feet of the seagulls.

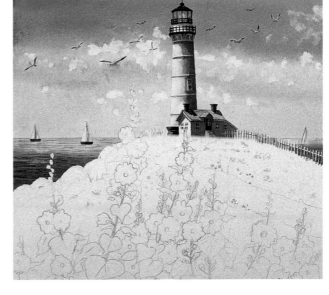

Step Five

Apply masking fluid to some of the foreground hollyhocks (mainly the small buds and stems, or any areas you feel will interfere with the smooth application of washes).

Lay in Burnt Sienna washes with a 1-inch flat brush for the rocks by the ocean. As the Burnt Sienna begins to dry, add Sepia to the darker rock shadows. Using the heel of the palette knife, scrape along the sunlit rocks to show sunlight and texture.

Use light washes of Yellow Ochre to create the pathway from the lighthouse. Scrape the path with the heel of your palette knife to suggest highlights. When this area is dry, lay in wet washes of Sap Green and Permanent Green with a 1-inch flat brush for grass areas. While the grass is wet, scrape areas with both the heel and tip of your palette knife to create grass texture. As the area is drying, use a no. 2 round and the above green mixture to suggest more grass, especially along the rocks facing the ocean and in and along the pathway. Allow this area to dry completely before removing the remaining mask.

Add rocks in the grass areas with Sepia and Burnt Sienna.

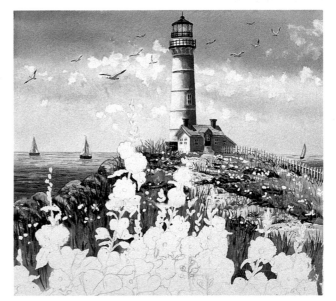

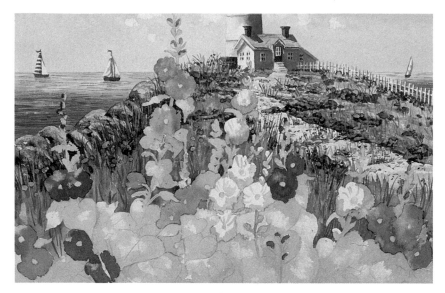

Step Six

Use Permanent Rose to fill in the white areas left by removing the masking fluid in the grass. This will suggest flowers among the grasses and on the pathway. Begin laying in loose, wet washes of Permanent Rose for the pink hollyhocks, Cobalt Blue for the shadows of the white hollyhocks and Permanent Red Deep for the red hollyhocks.

Use a mixture of Permanent Green and Spectrum Yellow (or Winsor Yellow) for the hollyhock foliage and leaves in the sunlight. Add Permanent Red Deep to detail the distant sailboats.

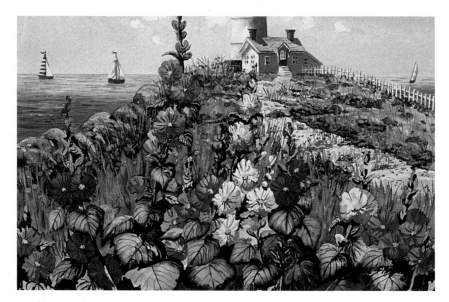

Step Seven

Lay in the shadow areas of the pink hollyhocks with a purple-hued mixture of Permanent Rose and Cobalt Blue. For the red hollyhocks, add Alizarin Crimson shadows. While the shadow areas of the hollyhocks are drying, create leaf shadows and veins using a no. 6 round loaded with Permanent Green and Ultramarine Blue.

When all areas are completely dry, add additional detail to the veins and lines in the flowers and leaves, using the same colors you used before, but with less water on the brush and heavier concentration of color.

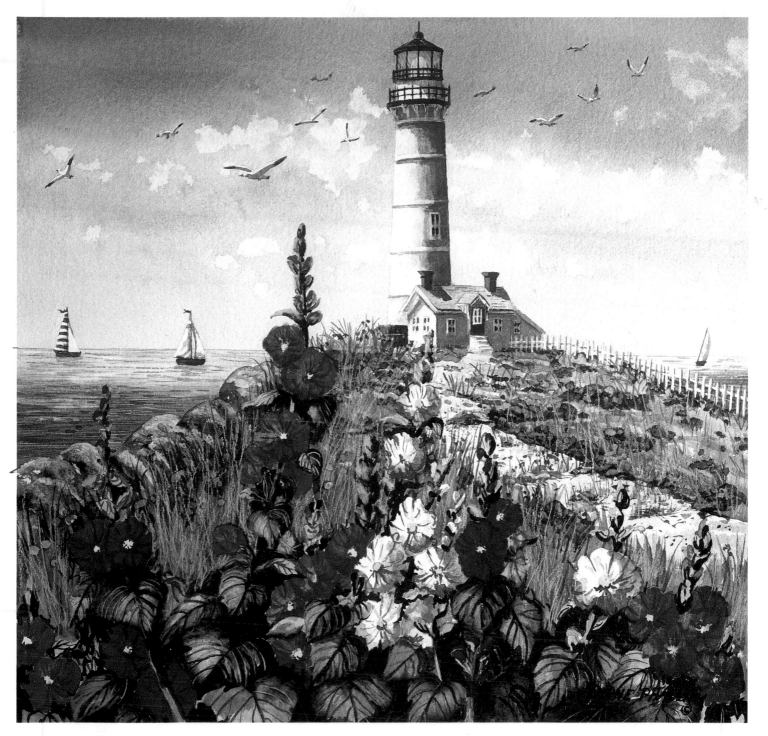

Fluorescent Glow

You can add an extra "glow" to your painting by adding loose, wet, quick washes of Fluorescent Magenta for the pink hollyhocks, Fluorescent Red for the red hollyhocks and Fluorescent Yellow for the leaves.

Since you may want additional contrast between the brightened flowers, randomly add some Straw Yellow watercolor pencil lines to define the hillside grass.

Mill Pond in the Spring

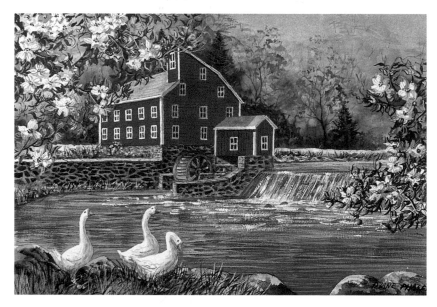

The red mill in this painting is a popular one located in Clinton, New Jersey. I stumbled upon it by accident while looking for a gas station. Little did I know my quick stop would lead to several hours of sketching and enjoying this wonderful spot on a spring day.

MATERIALS

- Tracing paper, pencil, eraser
- 15" × 22" 300 lb. Arches cold-pressed watercolor paper
- Artist's tape
- Masking fluid
- Rubber cement pick-up
- Tissues
- Palette knife
- Nail file
- White watercolor pencil (optional)

BRUSHES

- no. 1 round
- no. 2 round
- no. 6 round
- 1½-inch flat
- bristle brush

PALETTE

 Cadmium Yellow

 Yellow Ochre

 Burnt Sienna

 Burnt Umber

Sepia

 Cadmium Orange

 Alizarin Crimson

 Cadmium Red

 Cerulean Blue

Cobalt Blue

 Ultramarine Blue

 Winsor Blue

 Permanent Green

 Fluorescent Yellow gouache (optional)

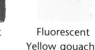

Step One

Transfer the drawing to your
watercolor paper.

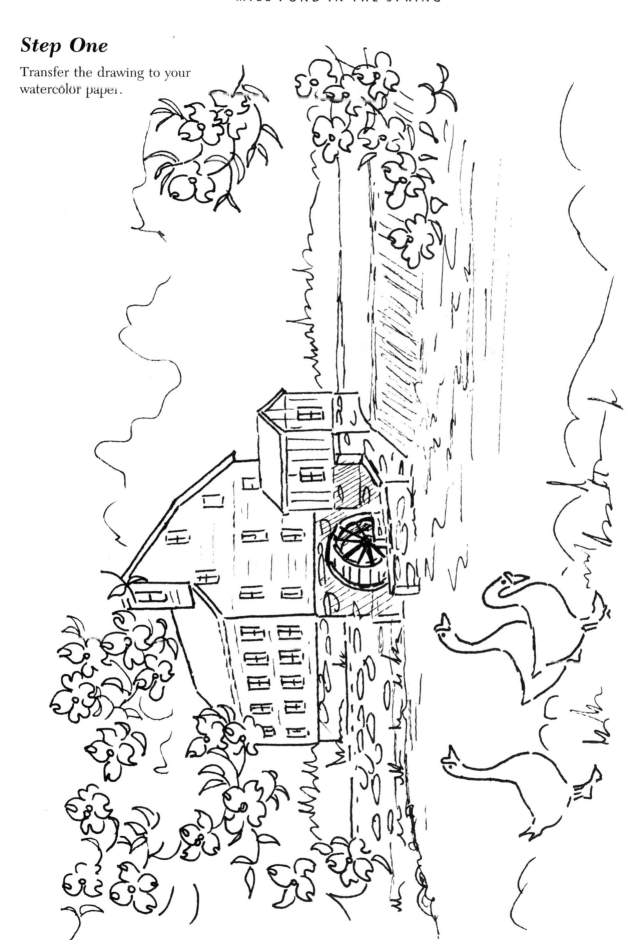

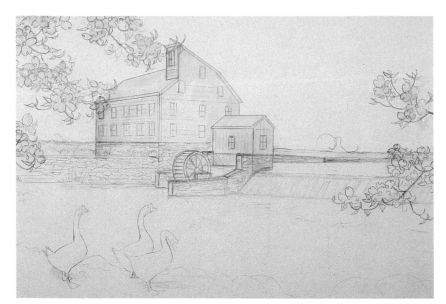

Step Two

Mask off areas that need to be protected from the background sky washes, such as the dogwood blossoms and the mill roof and sides.

Step Three

After the mask is completely dry, cover the entire paper with a very wet wash of clear water. Starting with a 1½-inch wash brush, add Cerulean Blue for the first layer of the sky area. Allow this to dry slightly, then add background greens with mixtures of Permanent Green, Ultramarine Blue, Fluorescent Yellow (optional) and Cadmium Yellow. Use a crumpled tissue to further suggest foliage texture. While the foliage is still damp, suggest branches with Sepia and a no. 2 round detail brush. When the paper is dry, use a very dry brush of Permanent Green and Ultramarine Blue to suggest dark foliage and fir trees around the mill and background. When the background is completely dry, remove the mask.

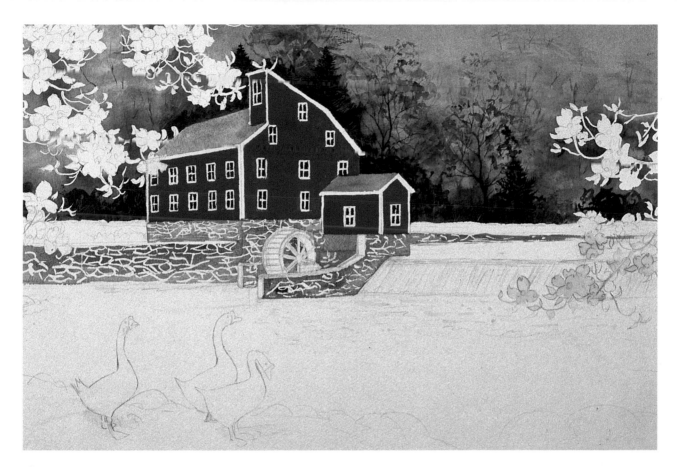

Step Four

Apply masking fluid to the windows and stonework of the mill and to the dogwood blossoms near the water. Also apply quick brushstrokes of masking fluid to the waterfall area. This will aid in the dry-brush application of the waterfall in step eight. Let these areas dry completely before beginning the initial mill washes.

Lay in wet washes of Cadmium Red for the mill wood. Using wet washes of Cerulean Blue and Burnt Umber, wash over the stonework areas on the mill and the walls by the water, as well as the roof of the mill. Add detail to the background trees and also in the windows of the mill with Burnt Umber. Further define the background foliage with a mix of Permanent Green and Ultramarine Blue, using a no. 6 round dry brush.

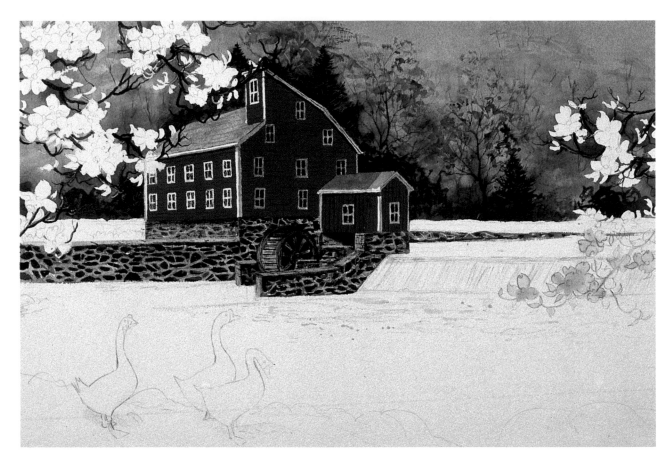

Step Five

Use a loose wash of Alizarin Crimson for the shadow reds of the mill and for wood grain texture in the light red (sunlit) areas. Use Cerulean Blue for the shadows of the mill roof, the whites around the windows, and any parts of the mill that face away from the sun. Using a mix of Cerulean Blue and Burnt Umber, wash over the stonework areas to blend in areas left white from masking—this will lend a gray tone to the mortar between the stones. Using Burnt Umber and a dry brush for stones that fall in shadow, define the stonework between the mortar lines; use a more diluted wash of Burnt Umber for stonework in sunny areas.

Paint in wood texture in the red shadow areas of the mill and in shaded windowpanes with a dry no. 1 detail brush and Winsor Blue. Use Burnt Umber for the branches of the dogwood trees and the water wheel. Apply a quick, wet wash of Yellow Ochre over the stonework in direct sunlight and the water wheel. Suggest shadows in the wheel with Burnt Umber, adding Winsor Blue in the darkest areas of shadows.

Step Six

Lay in a loose, wet wash of Cobalt Blue for the shadow areas of the dogwood blossoms. When these areas are dry, add detail to the centers of the blossoms with Cadmium Yellow and Permanent Green. Use a dry detail brush of Cobalt Blue to suggest veins in the petals. Fill in sunlit leaves with washes of Permanent Green and Cadmium Yellow. For the shadow greens and vein work, use Winsor Blue and Permanent Green. Use heavy dry-brush mixtures of Cadmium Yellow, Permanent Green and Winsor Blue for the brush and grass behind the stone walls, in front of the mill and below the stone walls along the water's edge. Mix Burnt Umber and Alizarin Crimson for the tip of each dogwood petal.

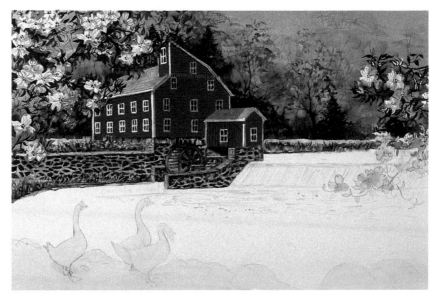

To prepare for the next stage, apply masking fluid over the foreground rocks and geese. Allow this to dry completely before beginning step seven.

Step Seven

Lay in very wet wash mixtures of Permanent Green, Cobalt Blue and Winsor Blue for the water. Working quickly, add some Cadmium Red to suggest a reflection of the mill at the water's edge—this reflection should be very subtle as churning water is not as reflective as a calm surface. Blot out texture in the waterfall and foam flowing into the river with a crumpled tissue. The areas where the water spills rapidly over the mini-waterfall will be very white and frothy.

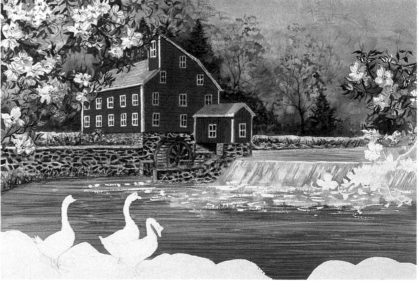

While the paint is still wet, use a nail file to scrape out lines that suggest ripples in the water. Once the paper begins to dry add more lines—these will appear lighter than those scraped while the paper was throughly wet. When the paper is completely dry remove all remaining masking fluid.

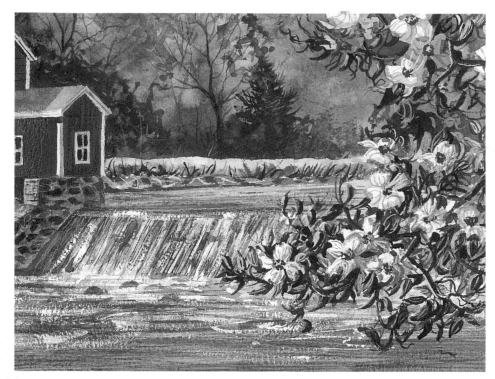

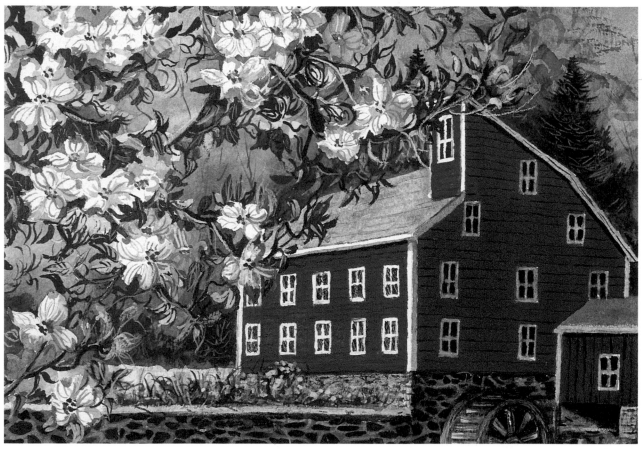

Details of steps five through seven.

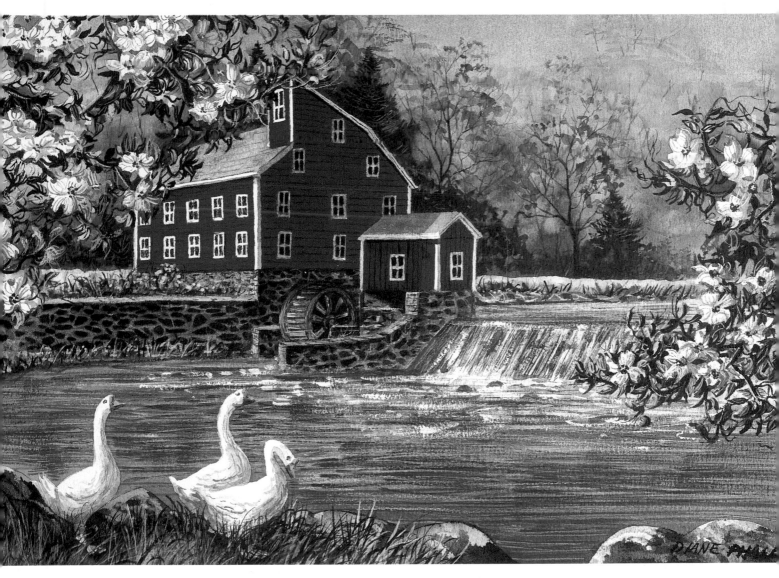

Step Eight

Lay in wet washes of Cobalt Blue on the geese and dogwood blossoms over the water. Add Cobalt Blue in a loose, quick wash over the stonework that is in shadow, being careful not to disturb the underlying paint. Using a drier brush of Cobalt Blue, add texture to the waterfall area and the shadow by the mill. When the waterfall is completely dry, use a bristle brush loaded with Winsor Blue to further establish and define the waterfall and water ripples. Continue to define the dogwood blossoms using the colors introduced to the blossoms in step six.

Fill in the beaks and feet of the geese with Cadmium Orange, adding shadows with Burnt Sienna.

Add Burnt Umber to the waterfall to suggest rocks under the fall and in the water. For the foreground rocks, begin with a wash of Burnt Sienna. Lay a wash of Burnt Umber over this intial wash to create shadows. Scraping with a palette knife will add more texture to the rocks. Suggest some grass in front of the rocks with Permanent Green. As the paper loses its shine, use the tip of the palette knife to scrape in grass at the bottom of the painting. Add more detail to the grass with a no. 1 round and a mixture of Permanent Green and Winsor Blue.

Finally, if desired you can use a white watercolor pencil to go over the water area for additional ripples. To make some of the green leaves among the dogwood blossoms pop out more, try adding a touch of Fluorescent Yellow to Permanent Green and laying in some extra color highlights among the darks.

Autumn Mill Pond

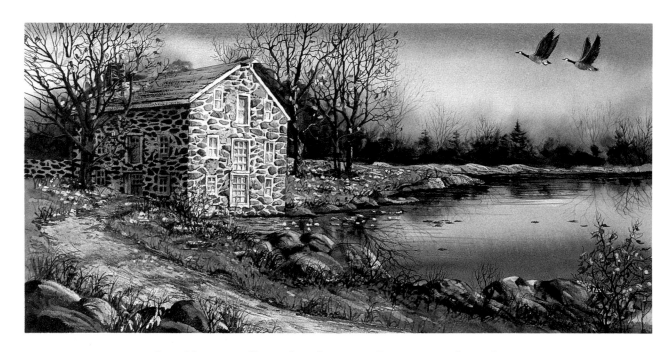

This old stone mill was found on one of my many side-road trips through Lancaster County. It was a wonderful autumn day with the sun just setting, its golden rays reflecting off the old mill's windows.

M A T E R I A L S

- Tracing paper, pencil, eraser
- 15″ × 30″ Arches 300 lb. cold-pressed watercolor paper
- Artist's tape
- Masking fluid
- Rubber cement pick-up
- Tissues
- Palette knife
- White watercolor pencil

BRUSHES
- no. 0 round
- no. 1 round
- no. 2 round
- no. 6 round
- 1-inch flat
- 1½-inch flat

PALETTE

 Naples Yellow New Gamboge Yellow Ochre Burnt Sienna Quinacridone Sienna Sepia

 Warm Sepia Quinacridone Pink Cerulean Blue Cobalt Blue French Ultramarine Sap Green

 Lamp Black Fluorescent Magenta gouache (optional)

88

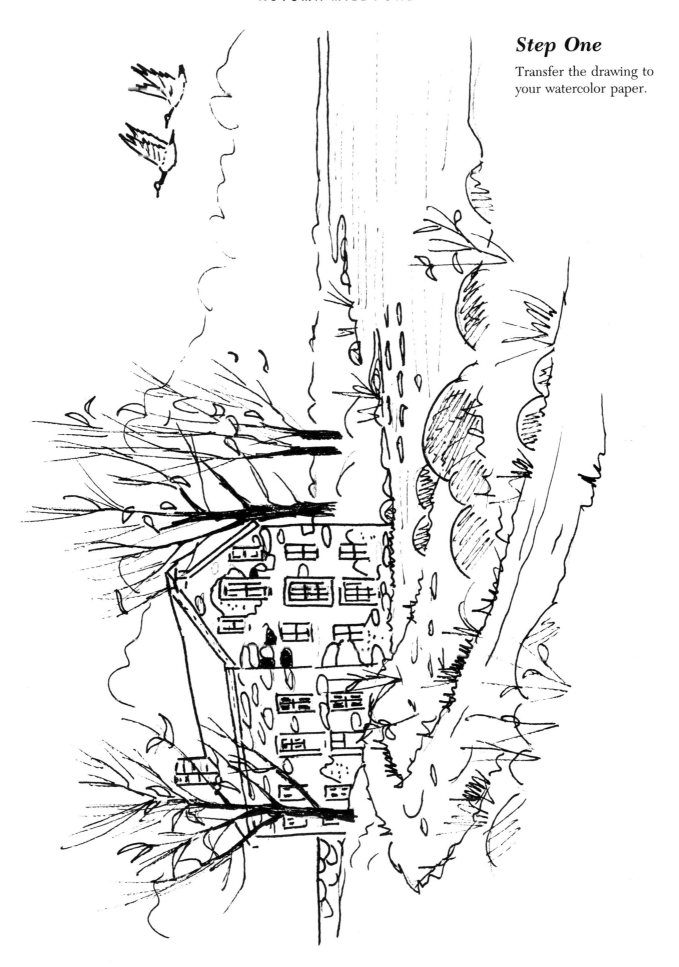

Step One

Transfer the drawing to your watercolor paper.

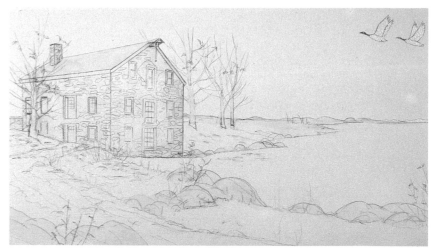

Step Two

Mask off the background area where the sky meets the rocks, and also the mill roof and sides, the foreground rocks, the leaves and the Canada geese.

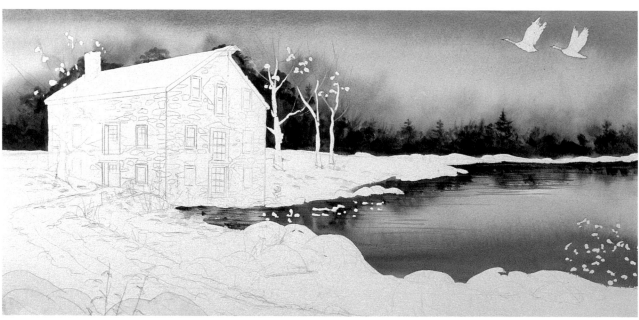

Step Three

Use a 1½-inch brush to apply a wet wash of Naples Yellow to the sky area. While this area is still wet, add Quinacridone Pink to the horizon and blend toward the tree line. Add a very small amount of Fluorescent Magenta—just enough to give an extra glow to the sunset.

While the sky is still wet but losing its shine, create a misty tree effect using a no. 6 round and starting with the very lightest shade—a mixture of Cobalt Blue and Quinacridone Pink.

For the foreground trees closest to the pond add a mixture of Warm Sepia and Quinacridone Pink. When this is completely dry, mirror the same colors used in the sky and background as reflections in the pond.

When the paper is once again dry, remove the mask from trees, mill, geese, rocks and bushes.

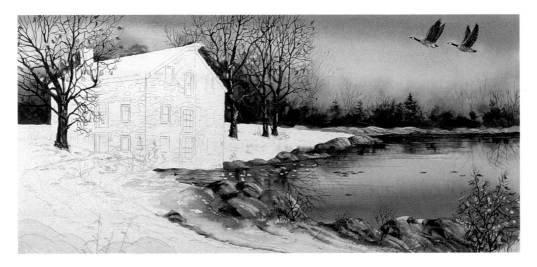

Step Four

Use Quinacridone Sienna in wet washes on the rocks surrounding the pond. While these washes are still wet, but beginning to dry, lay Warm Sepia in the shadow areas. Use the heel of your palette knife to scrape in rock texture and sunlight effects on the un-shaded rocks. You can also use crumpled tissue to blot out similar sunlight and texture effects while the wash is very wet.

To define the trees surrounding the mill, use a no. 2 round and Quinacridone Sienna for sunlit areas and Sepia for the shadows.

Further define the background and its reflection in the pond. Use Sepia for twigs and branches. Use New Gamboge and Quinacridone Sienna for background and reflected leaves.

For the wings of the two Canada geese in flight use a no. 1 round brush and Quinacridone Sienna mixed with Sepia. Paint their necks with Lamp Black.

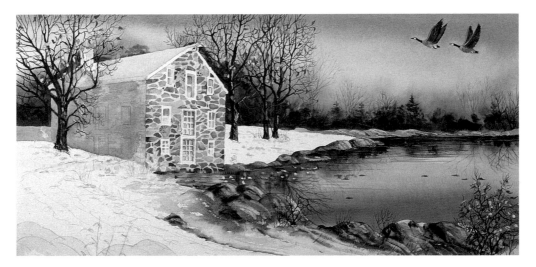

Step Five

Work around the whites of the windows in the mill with reflected sunset colors of Quinacridone Pink and New Gamboge, using a no. 1 round detail brush.

With a no. 6 round brush, detail some of the sunlit stones on the mill, starting with very light washes of Warm Sepia. Fill in the rest of the stones with random washes of Quinacridone Sienna, Cerulean Blue, Burnt Sienna and Yellow Ochre. Freely apply these colors, leaving the white of the paper between stones.

When this area is completely dry, lay in a very wet wash of Cerulean Blue over the sunlit stones using a 1-inch flat wash brush. This must be done quickly so that the intial washes of stonework are not disturbed, blending from the bottom of the mill to the roof line. This softens the overall effect of the rocks. Use a very wet wash of Cerulean Blue and Warm Sepia over the shadow side of the mill.

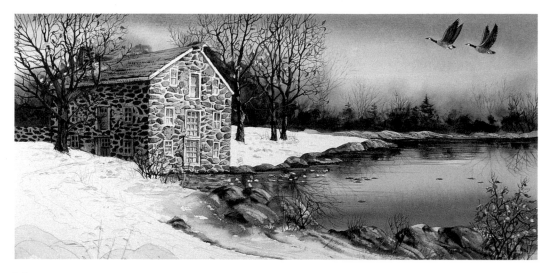

Step Six

Using a no. 0 or no. 1 round detail brush and Sepia, dry-brush the sunlit area of the mill's stonework, adding texture and shadow lines for definition around the stones. Also detail the mill stonework reflected in the pond, the twigs at the water's edge, and the window edges.

When the stone texture is completely dry, use a white watercolor pencil to quickly go over the stonework and window reflections for additional texture.

Paint the stonework that falls in shadow using Sepia to suggest stones and detail. Leave areas between the stones for mortar. Using a mixture of Cerulean Blue and Sepia, go over the entire shadow area of stonework to soften it as you did with the sunlit stones. At the same time wash in the roof of the mill.

When the roof is dry use a no. 2 round loaded with Sepia to suggest roof lines.

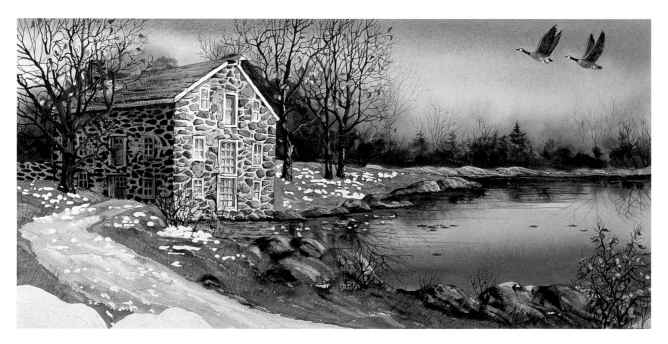

Step Seven

Lay in a wet wash of Sap Green for the grass areas, working around the leaves to lay in the grass. Lay in a wet wash of Yellow Ochre for the dirt pathway from the mill to the pond. When these washes are dry, remove all remaining masking fluid.

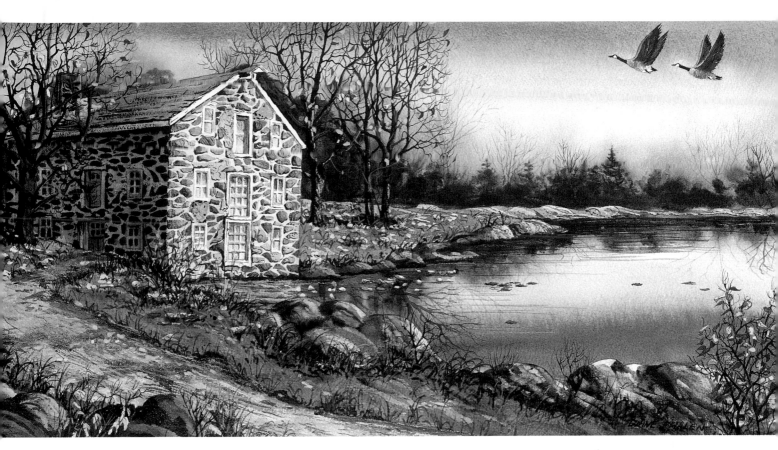

Step Eight

Fill in the fallen leaves in the grass and on the pathway with New Gamboge and Quinacridone Sienna. When this application is dry, use a no. 1 detail brush with Sap Green and French Ultramarine to suggest grass detail throughout the painting, especially in the fallen leaf areas. Add further definition to the dirt path with Burnt Sienna and a mixture of Sepia and Quinacridone Sienna. Paint in the foreground rocks with Quinacridone Sienna and Sepia.

Smiling Holsteins

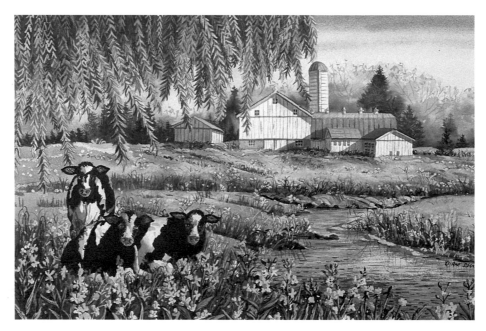

My husband Mike and I were traveling down a back road in Lancaster County when we came upon a farm called "Smiling Holsteins"—quite appropriately named, for in the field were three cows that did indeed appear to be smiling! The setting was so peaceful and serene that I just had to paint it, smiling cows and all.

MATERIALS

- Tracing paper, pencil, eraser
- 14″ × 22″ 300 lb. Arches cold-pressed watercolor paper
- Artist's tape
- Masking fluid
- Rubber cement pick-up
- Tissues
- Palette knife

BRUSHES

- no. 0 round
- no. 2 round
- no. 6 round
- 1-inch flat
- 1½-inch flat

PALETTE

Naples Yellow

Cadmium Yellow

Cadmium Yellow Deep

Winsor Yellow

Burnt Sienna

Raw Umber

Cerulean Blue

Cobalt Blue

Winsor Blue

Permanent Green

Phthalo Green

Lamp Black

Sepia

Permanent Rose

Step One

Transfer the drawing to your
watercolor paper.

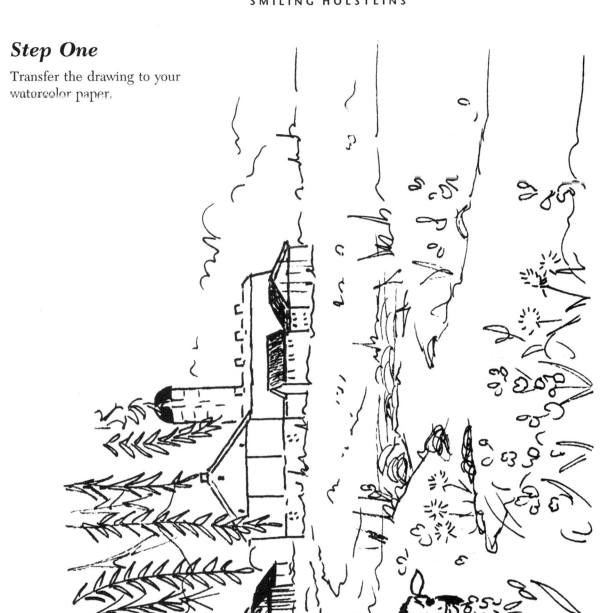

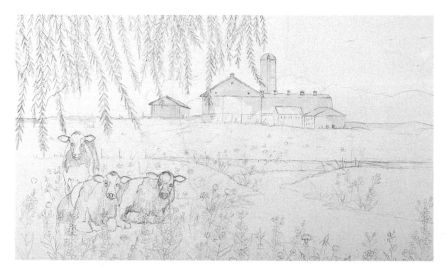

Step Two

Apply masking fluid to individual willow leaves, the barn and silo to protect these areas from the darker background washes.

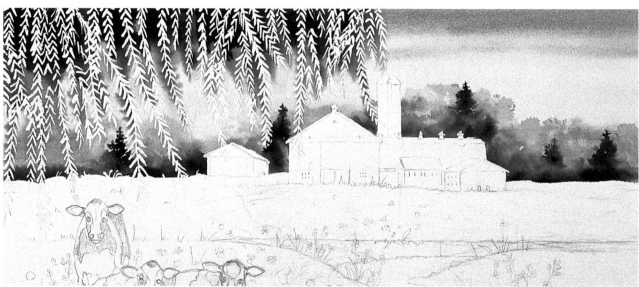

Step Three

Using a 1½-inch wash brush loaded with Naples Yellow, lay in the initial sky wash. While this wash is still completely wet, add Cerulean Blue across the top of the painting with a 1-inch flat brush, allowing it to blend with the Naples Yellow.

Step Four

Suggest background trees with Cerulean Blue and a no. 0 round detail brush. Use a no. 6 round brush and various mixtures of Winsor Yellow and Permanent Green to paint the leafy willow, softening the background leaves with Phthalo Green and blending these three colors for the darker shadows. While the paper is drying, continue to add shadows with a no. 2 round and Phthalo Green, further defining some leafy areas with a dry brush and Permanent Green. Add branches among the willow leaves with Burnt Sienna and a no. 0 round brush.

Add barn shadows with Cobalt Blue and a no. 2 round brush. For the roof, use a mixture of Cerulean Blue and Sepia. In the shadow areas of the roof, use more Sepia mixed with Cerulean Blue.

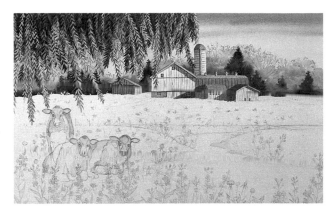

Mask off the foreground flowers and areas of the grass for background flowers using a no. 0 round brush. Also mask off the cow shapes so that the grass washes may be applied freely.

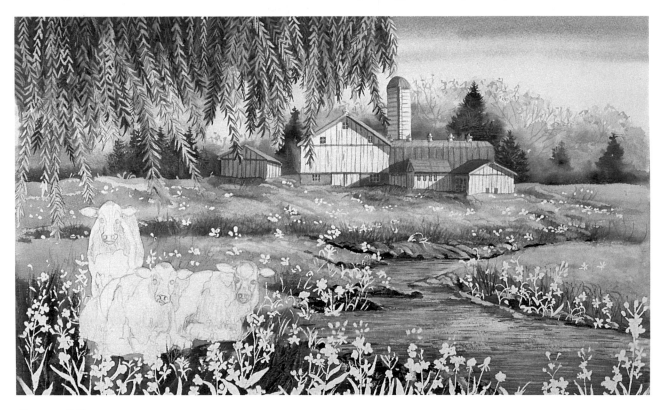

Step Five

Apply a wet wash of clear water on all areas of the grass. With a 1-inch flat brush, begin laying in wet, loose washes of Winsor Yellow mixed with a small amount of Cobalt Blue. For the shadow and foreground grass areas, mix in a little Phthalo Green. While the grass area is drying, use the heel of your palette knife to scrape in highlights. Use the tip of your knife in some areas to suggest individual grass blades.

Apply Burnt Sienna and some Sepia to the rocks around the stream. Use the heel of your palette knife to scrape in highlights. When this area is dry, paint in the stream with a loose wash of Cobalt Blue mixed with a small amount of Phthalo Green.

Scrape in ripples of water with your palette knife blade while the paper is drying. Let the paper dry completely before removing the masking fluid.

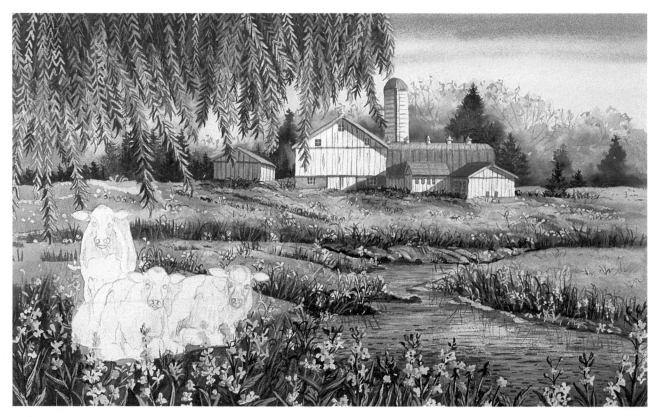

Step Six

Use a wet wash of Cadmium Yellow on a no. 2 round
brush for the yellow canola and dandelion flowers.
When the flowers are completely dry, use a no. 0 round
brush loaded with Phthalo Green to further detail the
grass. Fill in areas of grass and leaves left white from
the masking fluid with light, diluted washes of Winsor
Yellow and Cobalt Blue. Detail the leaf veins and shad-
ows with Phthalo Green and a no. 0 round brush. Add
flower shadows with Cadmium Yellow Deep. Continue
to define the grass and flower leaves and veins with
Phthalo Green.

Add more ripples to the stream with Cobalt Blue
and Phthalo Green.

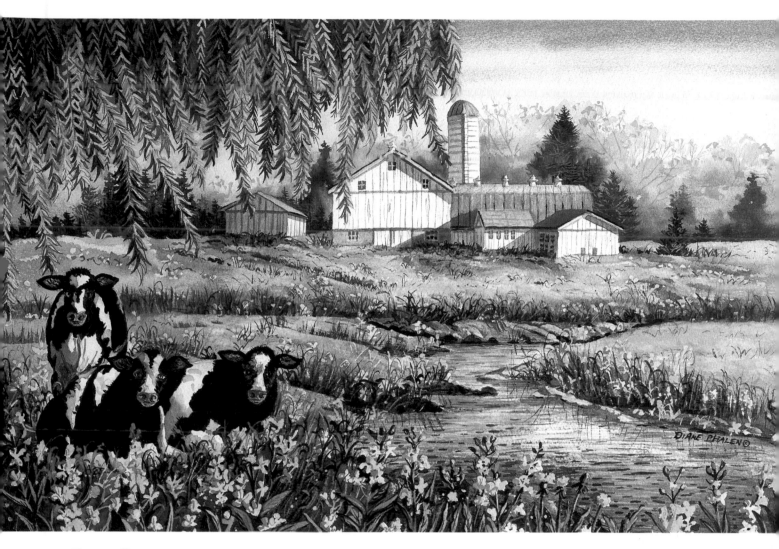

Step Seven

Use light washes of Cobalt Blue over the cows, switching to more concentrated, darker washes for areas that fall in shadow. When these washes are completely dry, use a no. 6 round and dry washes of Winsor Blue and Lamp Black to paint the cows' black patches. Detail the cows' eyes with a no. 0 round and light washes of the above mixture. Apply a soft, blending wash of Permanent Rose and some Raw Umber to the cows' noses.

Basalt Regional Library
99 Midland Avenue
Basalt CO 81621

Autumn Farewell

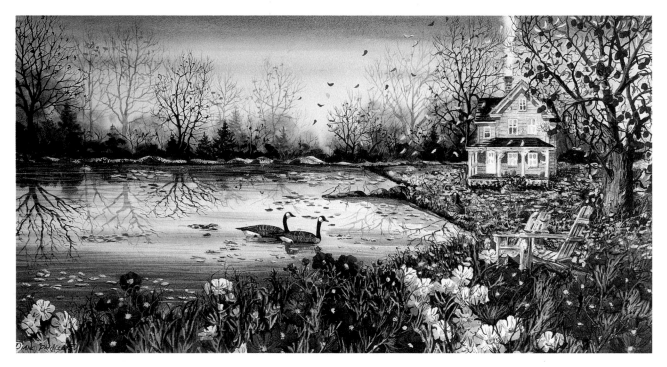

The pond was what first attracted me to paint this lovely setting.
The autumn leaves and Canada geese floating on the water spoke
of serenity as they made their last farewell of the season.

M A T E R I A L S

- Tracing paper, pencil, eraser
- 16″ × 30″ Lanaquarelle watercolor paper
- Artist's tape
- Masking fluid
- Rubber cement pick-up
- Tissues
- Nail file

BRUSHES
- no. 1 round
- no. 2 round
- no. 6 round
- 1½-inch flat

PALETTE

| Cadmium Yellow | Naples Yellow | New Gamboge | Burnt Sienna | Sepia | Warm Sepia | Cadmium Orange | Alizarin Crimson |

| Bordeaux | Cadmium Red | Permanent Rose | Rose Madder | Cerulean Blue | Cobalt Blue | Ultramarine Blue | Phthalo Green |

| Graphite Gray | Lamp Black | Fluorescent Magenta gouache (optional) |

Step One

Transfer the drawing to your
watercolor paper.

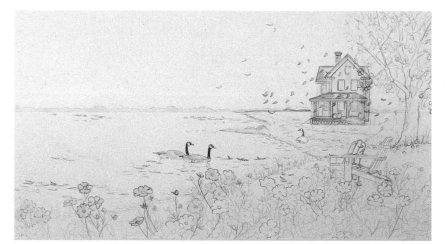

Step Two

Mask the areas of the design that should retain their whiteness, such as the house, apple tree leaves, leaves in the water, background rocks and foreground flowers.

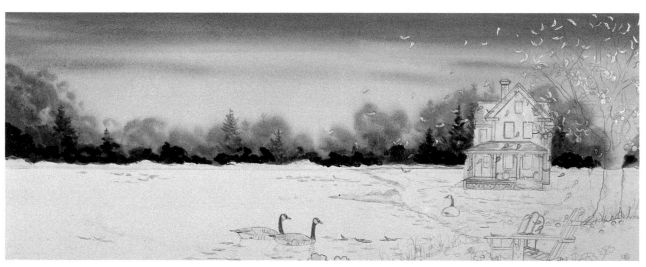

Step Three

Lay in the sky with a 1½-inch brush and a wash of Naples Yellow. Lay in a wash of Cobalt Blue and Rose Madder at the top of the horizon area, allowing it to blend into the Naples Yellow.

As the paper begins to lose its shine, add background trees using loose washes of Cerulean Blue, Warm Sepia and Alizarin Crimson. While the paper continues to dry, use Sepia and a no. 1 round to paint in bushes and Phthalo Green to suggest pines along the pond in the background.

A WORD OF CAUTION

You will notice I used a softer paper for this project— I really like the way the colors flow and mingle on the Lanaquarelle. The only downfall is that, because of the softness of the paper, my heavy use of masking fluid lifted areas of the paper when the mask was removed. I tested several different brands of masking fluid, and found this to be true in each instance. If you are afraid of tearing your paper you may wish to stick with the Arches paper, although testing new surfaces and mediums is a great way to expand your skills and develop new techniques.

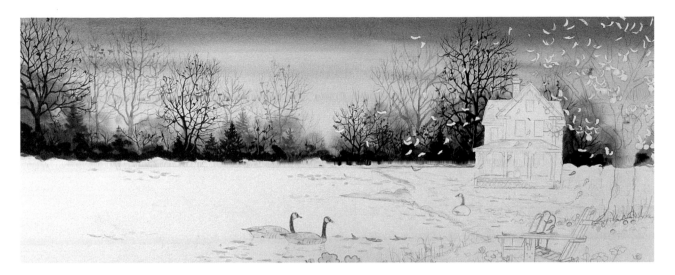

Step Four

Further define the distant background trees with Cerulean Blue and Sepia, using a no. 2 round detail brush. Use Sepia for the foreground branches and trees close to the water's edge. When the background is dry, remove the masking fluid from the house and apple tree.

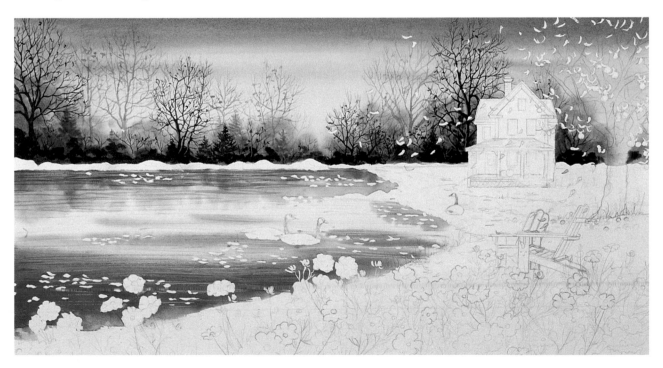

Step Five

The same colors that were applied in the sky area will reflect in the pond. Cover the entire pond with a very wet wash of Naples Yellow on a 1½-inch flat brush, then add Ultramarine Blue and a very small amount of Alizarin Crimson to the bottom area of the pond along the flower edge, blending toward the middle of the pond. While the paper is still wet, add reflecting trees along the water's edge, using a mixture of Sepia and Cerulean Blue. While the paper is still wet, scrape lines in the water with a nail file or the handle of your brush. As the paper loses its shine, scrape additional lines into the pond to suggest shimmers and reflections—these lines will be lighter than those you scraped while the paper was wetter.

When the paper is completely dry, remove the rest of the masking fluid.

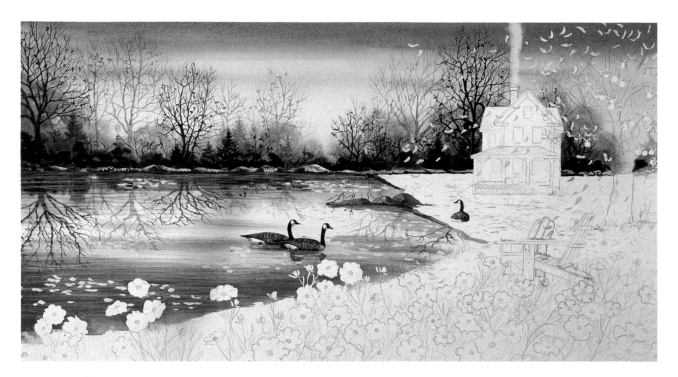

Step Six

Add mixtures of Burnt Sienna and Sepia to the shoreline rocks. Add the tree and rock reflections in the pond with Sepia on a no. 2 round brush. When the reflections are dry, add floating leaves with New Gamboge and Cadmium Orange, shading the undersides with Burnt Sienna. Use these color combinations for the flower centers and the apple tree leaves, both on the tree and on the ground.

Detail the geese in the water using Burnt Sienna and a dry brush of Sepia. Use Graphite Gray for their necks and tail feathers. Wipe out the area above the chimney of the house with clear water to suggest smoke.

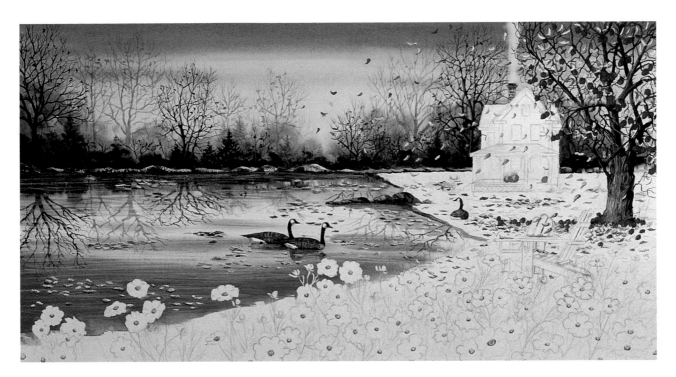

Step Seven

Using a no. 2 round, add fine details to the leaves in the pond, grass and trees with Burnt Sienna. Also apply Burnt Sienna to the shadow areas of the flower centers.

Use a no. 2 round brush loaded with Cadmium Red to paint the apples on and around the tree. Add Alizarin Crimson to the areas of the apples that fall in shadow, and add more apples completely in shadow using only Alizarin Crimson. Detail the branches and trunk of the apple tree with Sepia, blending and dry-brushing along the lighter areas of the tree bark.

Loosely define the fallen leaves in the grass with a mixture of New Gamboge and Burnt Sienna. Use Cadmium Orange for the pumpkins on the porch.

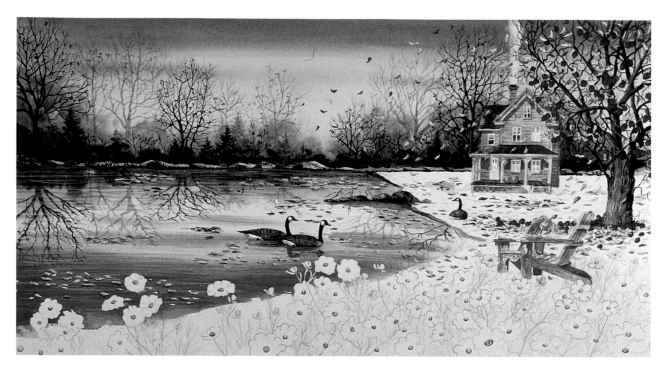

Step Eight

Apply a very loose wash of Cobalt Blue on the house and Adirondack chairs. When the first wash is dry, add darker shadow areas with a mixture of Cobalt Blue and Alizarin Crimson under the porch and eaves, and to suggest wood texture and siding lines on the house.

Use Graphite Gray for the roof of the house. Mask the leaves throughout the painting, as well as the stems of the cosmo flowers.

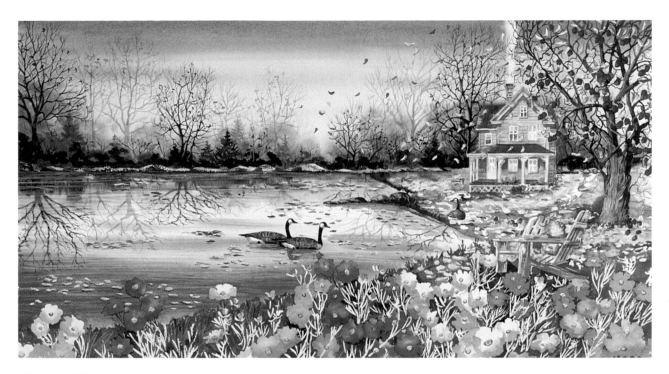

Step Nine

With a wet no. 6 round brush of Phthalo Green, very loosely wash around the grassy areas, working around the flowers and masked leaves. Use less water on your brush as you reach the bottom of the painting. Before removing the masking fluid from the cosmo stems, block in the flowers using Bordeaux for the maroon flowers and Permanent Rose for the pink flowers. Retain the white of the paper for the white flowers. Block in some shadow areas on the white flowers with Cobalt Blue, then blot the paint with crumpled tissue while still wet for a lacy effect.

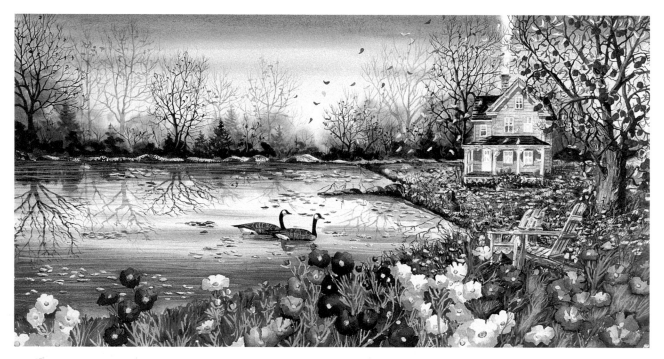

Step Ten

Further detail the roof and apple tree with Lamp
Black. Add more yellows and Burnt Sienna to the
grassy areas. Suggest grass between the fallen leaves
and around the front porch with Phthalo Green and
Ultramarine Blue. Use a mixture of yellows and
Phthalo Green for the flower stems, and to blend over
the previously established grasses.

 Add shadows to the cosmo flowers using Ultrama-
rine Blue and Permanent Rose for the pink flowers
and Ultramarine Blue and Bordeaux for the maroon
flowers.

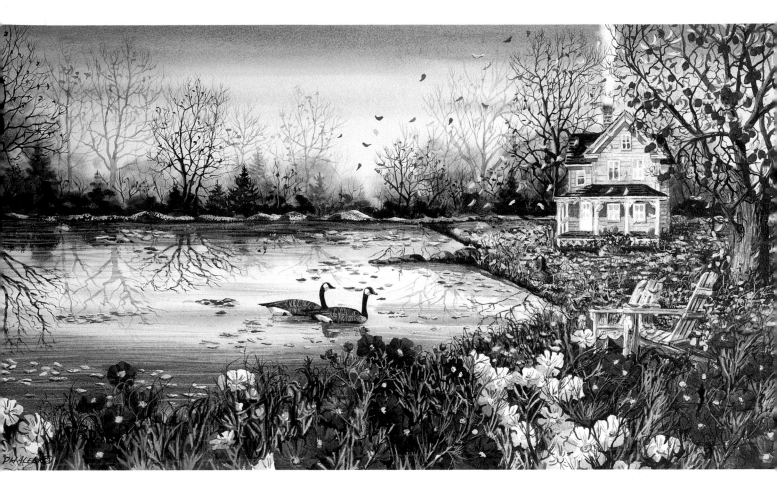

Step Eleven

Use a mixture of Ultramarine Blue and Phthalo Green for the dark shadows at the base of the flower stems. Randomly suggest weeds and stems along the water's edge and around the shadows. Detail the veins in the flower petals using more concentrated mixtures of the flower colors. Use a very loose wash of Fluorescent Magenta over the pink cosmo flowers to brighten and add contrast against the maroon flowers.

A Quilted View

My favorite painting theme is my ongoing American Quilt series. Every year I paint a special watercolor to celebrate the annual quilt show in Sisters, Oregon. The show brings together quilters from all over the West to view and admire quilts hanging from every storefront and fence rail in town. It is a beautiful sight to behold beneath the stately backdrop of the Three Sisters Mountains. This project is my special tribute to the 1996 celebration.

MATERIALS

- Tracing paper, pencil, eraser
- 22″ × 28″ 300 lb. Arches cold-pressed watercolor paper
- Artist's tape
- Masking fluid
- Rubber cement pick-up
- Tissues
- Palette knife

BRUSHES
- no. 0 round
- no. 2 round
- no. 6 round
- 1-inch flat
- 1½-inch flat

PALETTE

Cadmium Yellow	Cadmium Yellow Deep	New Gamboge	Winsor Yellow	Burnt Sienna	Burnt Umber	Raw Umber

Sepia	Alizarin Crimson	Cadmium Red	Permanent Rose	Cerulean Blue	Cobalt Blue	Manganese Blue

Permanent Green	Permanent White gouache	Raw Sienna	Ultramarine Blue	Fluorescent Magenta gouache (optional)

Step One

Transfer the drawing to your
watercolor paper.

Step Two

Apply masking fluid to the peaks of the mountains, the top sections of the windowpane that cross the sky and the edge of the curtain where it touches the sky area. Let the masking fluid dry completely before beginning step three.

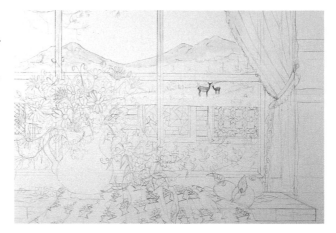

Step Three

Apply Ultramarine Blue across the sky area with a 1½-inch flat brush. Using a 1-inch flat brush, blend water along the bottom edge of the Ultramarine Blue so the sky blends toward the mountains. While the sky is wet, blot with a crumpled tissue to suggest clouds.

Suggest background pine branches with a mixture of Burnt Sienna and Burnt Umber. Use a no. 0 round brush and a mixture of

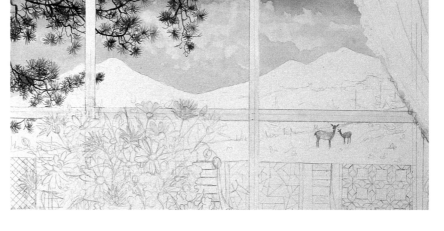

Permanent Green and Ultramarine Blue for the pine needles. Randomly add Winsor Yellow to some of the pine needles to create sunlit highlights.

Remove the masking fluid from the areas that were protected against the sky wash. In preparation for step four, apply masking fluid to the flowers, curtains and windowpane where they touch the mountains. Only mask off these areas if you wish to freely flow color in the application of the mountains. You may also carefully work around these areas without the use of masking fluid.

Step Four

Begin the mountains with washes of Ultramarine Blue and a small amount of Permanent Rose to create purple-hued shadows and lower elevations. While the area along the bottom of the mountains is still wet, add loose, wet washes of Permanent Green to suggest distant fir trees. When the mountain area is dry, add Sepia, Cerulean Blue and Burnt Umber to show areas where the snow has melted and exposed the rocks.

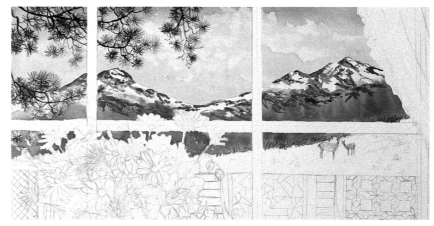

Scrape off some of the rock texture with the heel of your palette knife to suggest sunlit areas. When the mountains are dry, remove the masking fluid.

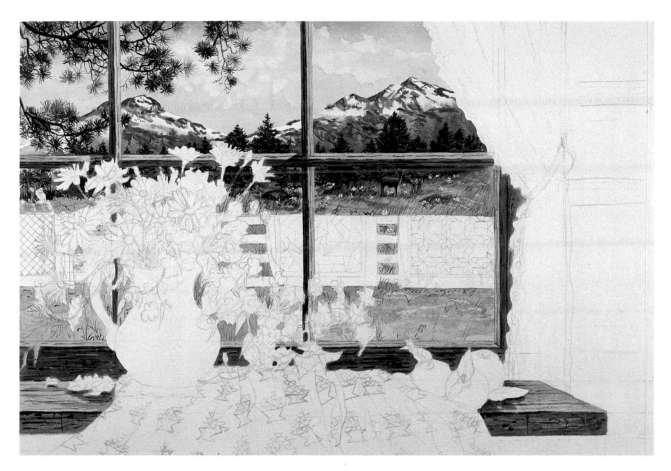

Step Five

Add detail to the foreground trees along the mountains using a mixture of Ultramarine Blue and Permanent Green on a no. 0 dry brush. Add detailed grasses around the quilts with the same colors, then apply a bright, loose wash of Winsor Yellow and Permanent Green over the entire grassy area using a 1-inch flat brush, working around the quilts and pitcher of flowers.

Add rocks among the grasses with Burnt Sienna and Sepia, using this same mixture to paint the deer and fawn. Add more detailed grasses to the foreground with Permanent Green and Ultramarine Blue. Use

Permanent White gouache and a no. 0 round brush to add white dots to the fawn's coat and also to suggest daisies among the grassy areas.

Using a 1-inch flat brush apply a wet wash of Raw Sienna over the woodwork around the window, including the top of the window ledge. When this is dry, use a mixture of Raw Sienna and Raw Umber for the shadow areas of wood on the windowpane and ledge. When completely dry, use the mixture of Raw Sienna and Raw Umber in the lighter, sunlit areas to create wood texture. Suggest wood texture in the shadow areas with Raw Umber.

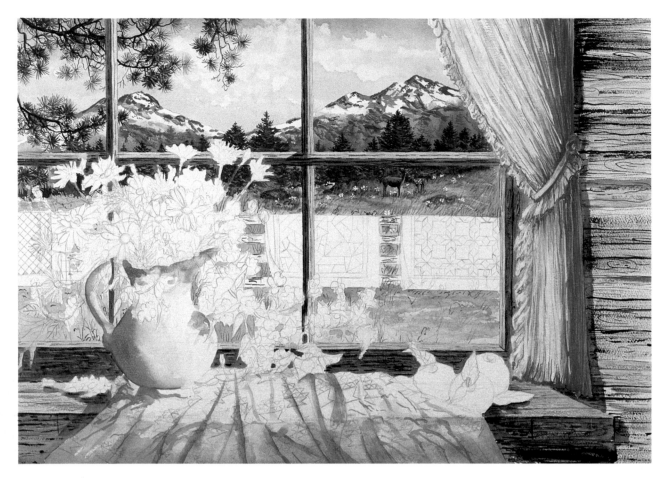

Step Six

Using a 1-inch flat brush, wet the curtains with clear water. Apply a mixture of Cobalt Blue, Manganese Blue and Permanent Rose to the edge of the curtain farthest from the window, allowing the color to blend toward the sunlit side of the curtain. While the paper is drying, continue to add the folds of the curtain with the same colors and a no. 2 brush. Use the same technique and colors on the pitcher and the quilt on the window ledge. Blot areas with a tissue as you are working to soak up excess water and create added texture. Let this dry completely.

Add very light washes of Raw Sienna among the curtain folds—this will suggest sheer curtains that allow the windowpane and woodwork to peek through. When this area is completely dry, use a dry 1-inch flat brush loaded with white gouache and quickly go over the curtain to further suggest sheerness and texture.

The areas of the curtain pulled away from the window are receiving less light and are folded on themselves; therefore they are less sheer. If needed, add more lines with a mixture of Cobalt Blue, Manganese Blue and Permanent Rose to create deeper shadows in the curtain folds.

Using a flat 1-inch dry brush and Sepia, suggest wood grain textures in the log cabin wall. Further detail the log walls with a no. 0 dry brush of Sepia. Use light washes of Raw Sienna between the logs. Use dark, wet washes of Sepia to cast shadows from the curtains onto the wood. Use the same colors on the fence where the quilts are hung. Allow this area to dry completely before beginning step seven.

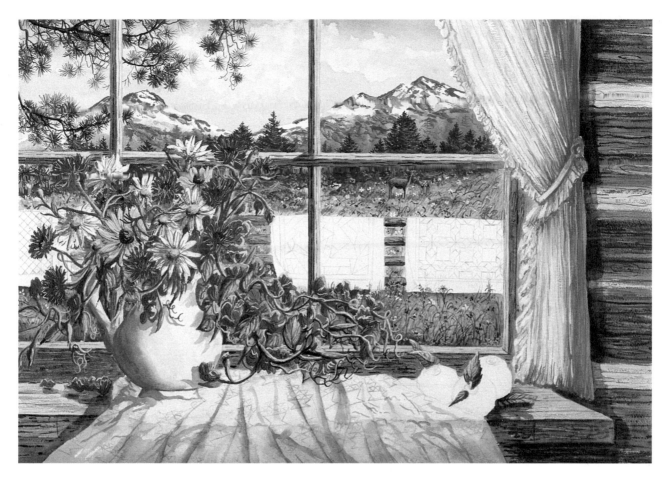

Step Seven

Finish the wood with varying wet mixtures of Burnt Sienna and Sepia, being careful not to disturb the underlying wood grains. If needed, detail additional wood texture lines with Sepia and a no. 0 brush.

Add a mixture of Cerulean Blue and Sepia to the shadows and underside of the wooden fence.

Lay in some Cobalt Blue shadows for daisies in the pitcher. Use New Gamboge for the centers. For the purple cornflowers use Cobalt Blue and Permanent Rose. Use Alizarin Crimson and Permanent Rose for the maroon cornflowers. Use Permanent Rose or a mixture of Permanent Rose and Fluorescent Magenta (optional) for the sweet peas. Use heavier concentrates of each color and less water, plus a little Cobalt Blue, to add shadows and detail in the flowers. The Cobalt Blue will give the shadows a nice purple cast. In addition, mix some white gouache and Permanent Rose for the flowers closest to the sun coming through the window. Use Alizarin Crimson to show petal veins.

The yellow brown-eyed Susan is done with Cadmium Yellow and New Gamboge. The shadows are Cadmium Yellow Deep. The center is Burnt Sienna, with Sepia shadows.

While all the colors of the wildflower bouquet are on your palette, add a drop of Permanent White gouache to each; this will make the wildflower colors opaque. Use these colors to suggest wildflowers in background grasses.

Lay in a mixture of Permanent Green and Winsor Yellow for the leaves and vines in the flower pitcher. While this is drying, add Cobalt Blue for the shadows. When completely dry, add details and dark shadows with Ultramarine Blue and Permanent Green. Also fill in more grass detail outside the window and under the quilts.

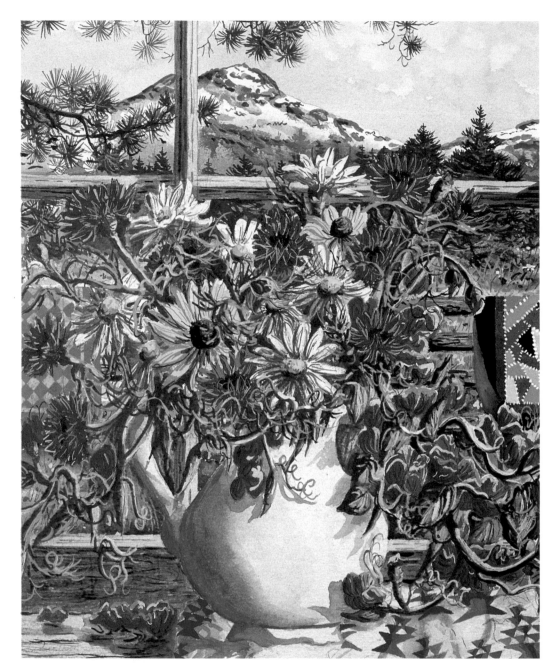

Detail of the flowers.

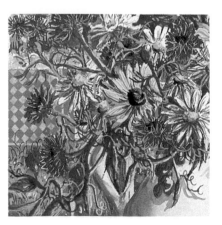

Step Eight

Complete the quilt hanging over the far left side of the fence with alternating blocks of Permanent Rose and a Permanent Rose and Cobalt Blue mixture.

Step Nine

The middle quilt hanging over the fence has a Crazy Quilt design. To paint this you may use random mixtures made from colors already on your palette. After adding color to each block, let dry, then apply white gouache with a no. 0 detail brush to suggest stitching.

The quilt on the far right is done in a pattern known as Lemoyne Star. Alternate the star points with Cadmium Yellow Deep and a mixture of Permanent Green and Winsor Yellow. Use a mixture of Ultramarine Blue and Permanent Green for the background quilt color and New Gamboge for the border stripes.

Step Ten

Paint the baskets on the window ledge quilt (this design is simply called a Basket Quilt) using a no. 2 brush and Cobalt Blue for the light areas and Ultramarine Blue for the baskets in shadow.

Use a no. 6 round and Cadmium Red mixed with a little New Gamboge to create red, juicy apples. For the darker shadows use Alizarin Crimson. For the leaves use Permanent Green and Winsor Yellow, adding Ultramarine Blue shadows.

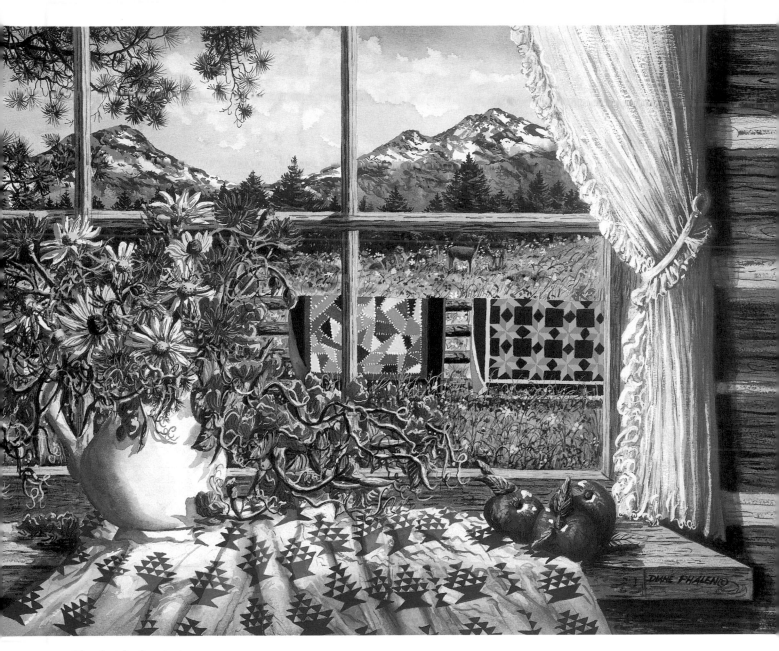

The finished painting.

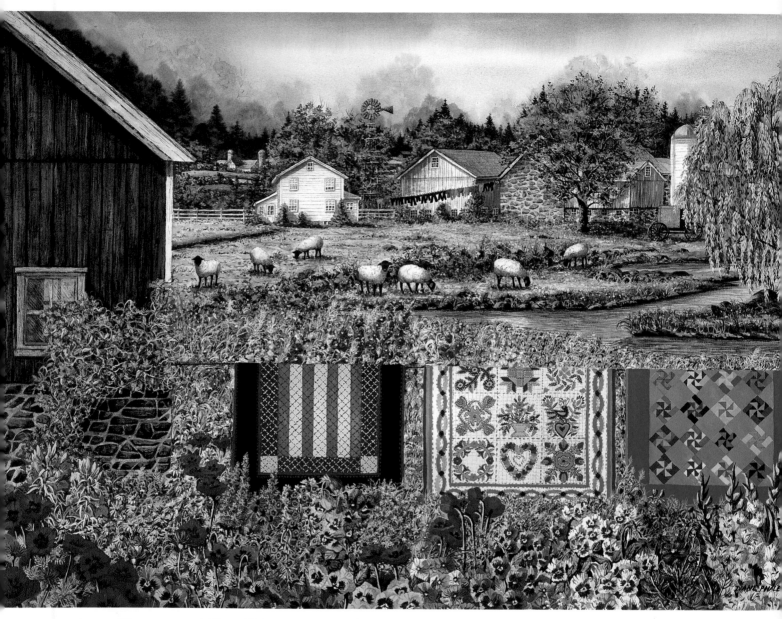

AMISH NEIGHBORS, 29″×41″ (74cm×104cm)

While driving my favorite back roads with my husband Mike on a beautiful April day in Lancaster, Pennsylvania, I saw several black-faced sheep in a farmer's field. This was the inspiration for "Amish Neighbors." We were fortunate to have driven by on a Monday, wash day, and seen the family wash airing on the line.

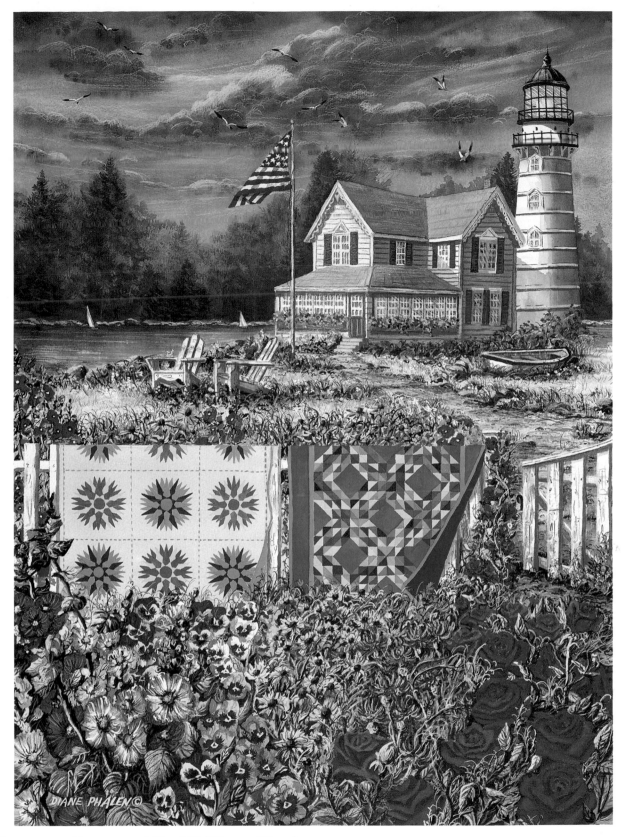

SHORELINE TREASURE, 22″ × 30″ (56cm × 76cm)

I wanted to combine my love of ocean sunsets with two ocean quilt patterns called Mariner's Compass and Ocean Waves. The lighthouse was inspired by one at *Cape Elizabeth in Maine. The Adirondack chairs are waiting for someone to come and sit and enjoy this magnificent sunset.*

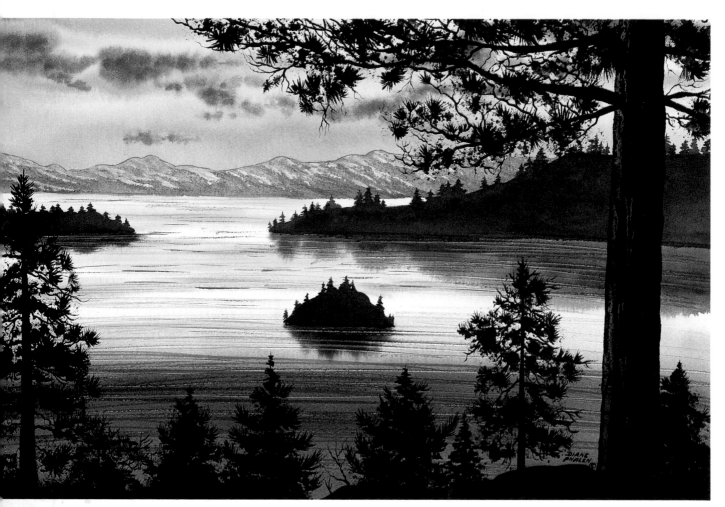

LAKE TAHOE, CALIFORNIA SUNRISE,
15″ × 22″ (38cm × 56cm)

· *My husband and I got up at three A.M. to wait for the sunrise over Lake Tahoe. This is one of my very favorite spots. The quiet and serenity of this beautiful scene was awesome.*

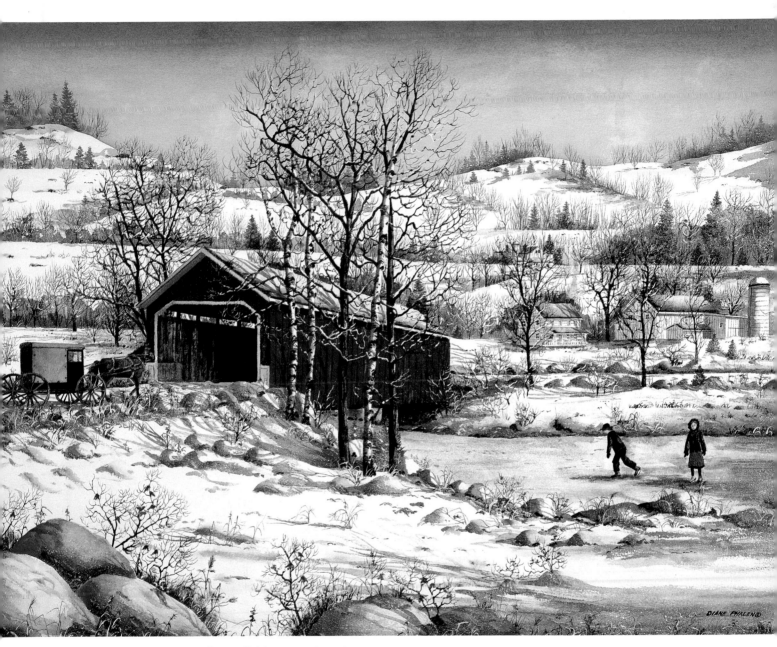

WINTER CROSSING, 22" × 30" (56cm × 76cm)

It's a cold crisp day in January. The ground is frozen and covered with snow. The Amish children are enjoying ice skating on the frozen creek and thinking about heading home for a warm cup of hot chocolate. Winter was always my favorite season growing up in Pennsylvania. It was an exciting time of ice skating, sledding, building snow forts and just enjoying the snow.

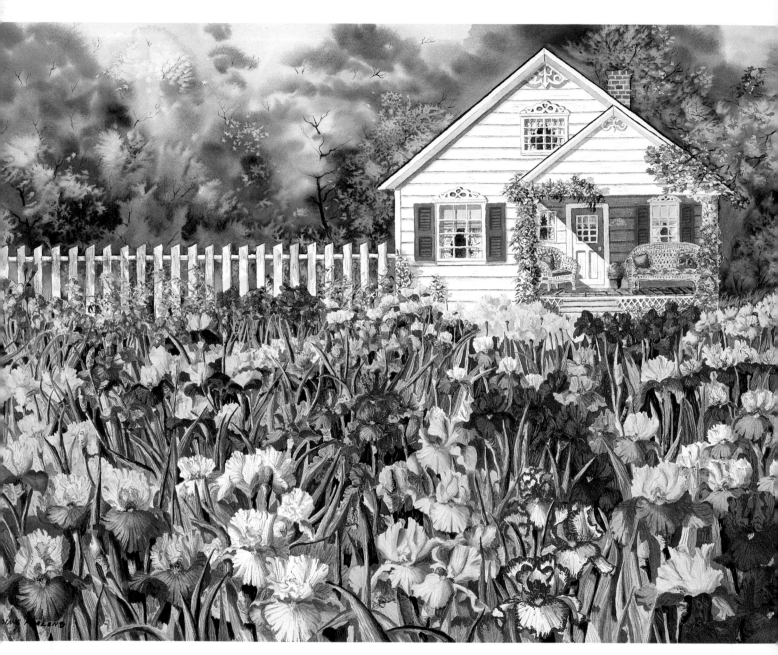

COTTAGE IRISES, 22" × 30" (56cm × 76cm)

*One of my favorite flowers is the beautiful iris. I love
its ruffled lacy edges and mutiple colors. It is a stately
flower. I am fortunate to live close to Schreiner's Iris
Farm in Salem, Oregon, where I got much of the inspi-
ration for this painting. The owner of this little cottage
likes irises too.*

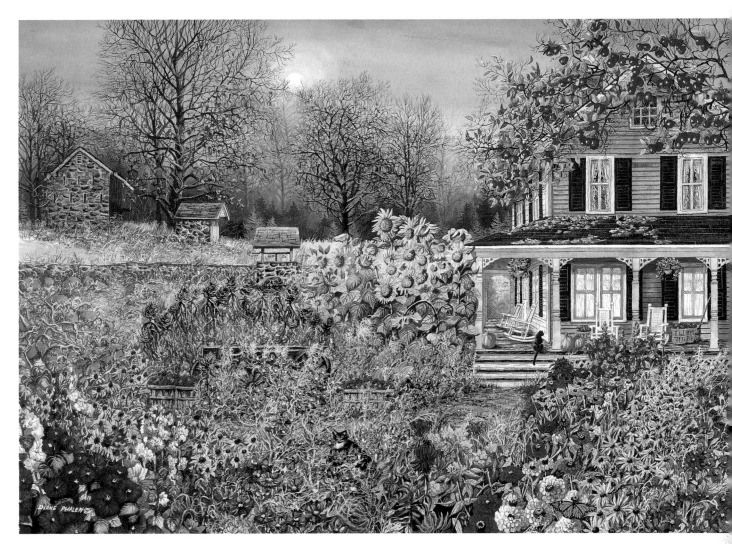

Autumn Mist, 29″ × 41″ (74cm × 104cm)

*The combined smells of apples and leaves as they gently
fall to the earth and the chimney smoke from the farm-
house can only mean one thing—autumn is in the air!
The misty pink of evening's dusk burnishes the country-
side in gold. The garden is in full bloom with the last
of summer before Jack Frost pays a visit.*

INDEX

More Great Books for Beautiful Watercolors!

Step-By-Step Guide to Painting Realistic Watercolors—Now even the beginning artist can create beautiful paintings to be proud of! Full-color illustrations lead you step by step through 10 projects featuring popular subjects—roses, fruit, autumn leaves and more. *#30901/$27.99/128 pages/230 color illus.*

The North Light Illustrated Book of Watercolor Techniques—Master the medium of watercolor with this fun-to-use, comprehensive guide to over 35 painting techniques—from basic washes to masking and stippling. *#30875/$29.99/144 pages/500 color illus.*

Capturing Light in Watercolor—Evoke the glorious "glow" of light in your watercolor subjects! You'll learn this secret as you follow step-by-step instruction demonstrated on a broad range of subjects—from sun-drenched florals, to light-filled interiors, to dramatic still lifes. *#30839/$27.99/128 pages/182 color illus.*

Creative Light and Color Techniques in Watercolor—Capture vibrant color and light in your works with easy-to-follow instruction and detailed demonstrations. Over 300 illustrations reveal inspiring techniques for flowers, still lifes, portraits and more. *#30877/$21.99/128 pages/325 color illus./paperback*

Watercolorist's Guide to Mixing Colors—Say goodbye to dull, muddled colors, wasted paint and ruined paintings! With this handy reference you'll choose and mix the right colors with confidence and success every time. *#30906/$27.99/128 pages/140 color illus.*

Painting Watercolor Portraits—Create portraits alive with emotion, personality and expression! Popular artist Al Stine shows you how to paint fresh and colorful portraits with all the right details—facial features, skin tones, highlights and more. *#30848/$27.99/128 pages/210 color illus.*

Painting Greeting Cards in Watercolor—Create delicate, transparent colors and exquisite detail with 35 quick, fun and easy watercolor projects. You'll use these step-by-step miniature works for greeting cards, framed art, postcards, gifts and more! *#30871/$22.99/128 pages/349 color illus./paperback*

Painting Watercolors on Location With Tom Hill—Transform everyday scenes into exciting watercolor compositions with the guidance of master watercolorist Tom Hill. You'll work your way through 11 on-location projects using subjects ranging from a midwest farmhouse to the Greek island of Santorini. *#30810/$27.99/128 pages/265 color illus.*

Art to Go Series—Take a trip around the world through the eyes of some of today's best artists! You'll learn tips and techniques to turn on-site impressions into completed paintings. Plus, eight blank postcards let you share your experiences with friends and family. Each book is 76 pages long with 200 color illustrations and a sturdy spiral-bound cover.

A Traveler's Guide to Painting in Watercolors—*#30799/$18.99*

A Traveler's Guide to Painting in Oils—*#30827/$18.99*

Splash 4: The Splendor of Light—Discover a brilliant celebration of light that's sure to inspire! This innovative collection contains over 120 full-color reproductions of today's best watercolor paintings, along with the artists' thoughts behind these incredible works. *#30809/$29.99/144 pages/124 color illus.*

Learn Watercolor the Edgar Whitney Way—Learn watercolor principles from a master! This one-of-a-kind book compiles teachings and paintings by Whitney and 15 of his now-famous students, plus comprehensive instruction—including his famed "tools and rules" approach to design. *#30927/$22.99/144 pages/130 color illus./paperback*

Painting Realistic Watercolor Textures—Add depth, weight and realism to your art as you arm yourself with the knowledge to create lifelike textures and effects. A range of easy-to-do techniques are covered in a step-by-step format designed for both beginning and advanced painters. *#30761/$27.99/128 pages/197 color illus.*

Basic People Painting Techniques in Watercolor—Create realistic paintings of men, women and children of all ages as you learn from the demonstrations and techniques of 11 outstanding artists. You'll discover essential information about materials, color and design, as well as how to take advantage of watercolor's special properties when rendering the human form. *#30756/$17.99/128 pages/275+ color illus./paperback*

Becoming a Successful Artist—Turn your dreams of making a career from your art into reality! Twenty-one successful painters—including Zoltan Szabo, Tom Hill, Charles Sovek and Nita Engle—share their stories and offer advice on everything from developing a unique style, to pricing work, to finding the right gallery. *#30850/$24.99/144 pages/145 color illus./paperback*

In Watercolor Series—Discover the best in watercolor from around the world with this inspirational series that showcases works from over 5,000 watercolor artists. Each minibook is 96 pages long with 100 color illustrations.

People—*#30795/$12.99*

Flowers—*#30797/$12.99*

Places—*#30796/$12.99*

Abstracts—*#30798/$12.99*

Watercolor: You Can Do It!—Had enough of trial and error? Then let this skilled teacher's wonderful step-by-step demonstrations show you techniques it might take years to discover on your own. *#30763/$24.99/176 pages/163 color, 155 b&w illus./paperback*

How to Capture Movement in Your Paintings—Add energy and excitement to your paintings with this valuable guide to the techniques you can use to give your artwork a sense of motion. Using helpful, step-by-step exercises, you'll master techniques such as dynamic composition and directional brushwork to convey movement in human, animal and landscape subjects. *#30811/$27.99/144 pages/350+ color illus.*

Creative Watercolor Painting Techniques—Discover the spontaneity that makes watercolor such a beautiful medium with this hands-on reference guide. Step-by-step demonstrations illustrate basic principles and techniques while sidebars offer helpful advice to get you painting right away! *#30774/$21.99/128 pages/342 color illus./paperback*

Creative Watercolor: The Step-by-Step Guide and Showcase—Uncover the innovative techniques of accomplished artists as you get an inside look at the unending possibilities of watercolor. You'll explore a wide spectrum of nontraditional techniques while you study step-by-step projects, full-color galleries of finished work, technical advice on creating professional looking watercolors and more. *#30786/$29.99/144 pages/300 color illus.*

Other fine North Light Books are available from your local bookstore, art supply store, or direct from the publisher. Write to the address below for a FREE catalog of all North Light Books. To order books directly from the publisher, include $3.50 postage and handling for one book, $1.50 for each additional book. Ohio residents add 6% sales tax. Allow 30 days for delivery.

North Light Books
1507 Dana Avenue
Cincinnati, Ohio 45207
VISA/MasterCard orders call TOLL-FREE
1-800-289-0963

Prices subject to change without notice. Stock may be limited on some books.

Write to this address for information on *The Artist's Magazine*, North Light Books, North Light Book Club, Graphic Design Book Club, North Light Art School, and Betterway Books. To receive information on art or design competitions, send a SASE to Dept. BOI, Attn: Competition Coordinator, at the above address.

8548